MODERN
Roots

Today's Quilts from Yesterday's Inspiration

12 Projects Inspired by Patchwork from 1840 to 1970

Bill Volckening

stashBOOKS®

an imprint of C&T Publishing

Text copyright © 2016 by Bill Volckening

Text, photography, and artwork copyright © 2016 by C&T Publishing, Inc.

Publisher: Amy Marson

Creative Director: Gailen Runge

Editor: Lynn Koolish

Project instructions created by Debbie Rodgers, except as noted

Technical Editors: Debbie Rodgers and Alison M. Schmidt

Cover/Book Designer: April Mostek

Production Coordinator: Tim Manibusan

Production Editor: Alice Mace Nakanishi

Illustrator: Freesia Pearson Blizard

Photo Assistant: Sarah Frost

Style photography by Nissa Brehmer and instructional photography by Diane Pedersen, unless otherwise noted

Published by Stash Books, an imprint of C&T Publishing, Inc., P.O. Box 1456, Lafayette, CA 94549

Library of Congress Cataloging-in-Publication Data

Names: Volckening, Bill, 1966- author.

Title: Modern roots--today's quilts from yesterday's inspiration : 12 projects inspired by patchwork from 1840 to 1970 / Bill Volckening.

Description: Lafayette, CA : C&T Publishing, Inc., 2016. | Includes bibliographical references.

Identifiers: LCCN 2015044372 | ISBN 9781617452031 (soft cover)

Subjects: LCSH: Patchwork--Patterns. | Quilting--Patterns. | Patchwork quilts--United States.

Classification: LCC TT835 .V65 2016 | DDC 746.46/041--dc23

LC record available at http://lccn.loc.gov/2015044372

Printed in China

10 9 8 7 6 5 4 3 2 1

Contents

I fell in love with my first antique quilt more than 25 years ago. It was a very fine object, made in the middle of the nineteenth century and discovered in Kentucky. The quilt was soft, thin, and densely quilted. It was in good condition, intricately stitched together with many small pieces of solid fabrics in Turkey red, overdyed green, cheddar orange, and white. The pattern was known as New York Beauty, and it included sunburst motifs with numerous sharp points radiating from curved patches.

"It looks so modern!" I said, completely enthralled by the quilt's dynamic graphic design.

The seller, Shelly Zegart, talked about displaying quilts on the walls as works of art. Quilts could be hung like large, modern paintings. She used the term "masterpiece" to describe certain ones. Ever since then, I've collected antique and vintage quilts for wall display, paying close attention to their modern characteristics.

Quilts were originally made as domestic, decorative objects, to keep people warm and dress the beds. Early American quilts were elegant objects made by affluent families who could afford the taxed, imported fabrics. There were many styles of bedcoverings, such as whole cloth, appliqué chintz and embroidered counterpanes, woven coverlets, and bed rugs.

Around 1800, geometric patchwork quilts started to appear in America. They were modern looking, with basic designs and bold colors. These quilts are scarce. When a remarkable wool quilt from Rhode Island surfaced on eBay in March 2011, a bidding frenzy ensued. The geometry is simple—squares, triangles, and diamonds made into stars. Most striking is the coral background of the center panel. It jumps out against the shiny blue wool around the edges.

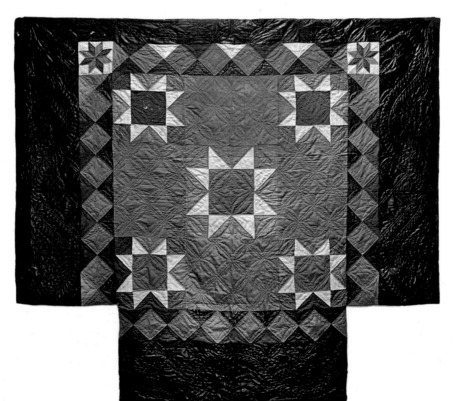

Star Quilt, wools, unknown maker, Rhode Island, c. 1800
Photo by Bill Volckening

Periods of American quiltmaking had representative styles, similar to periods in art history. There were also periods when quiltmaking was incredibly popular and many quilts were made. Around the 1840s, there was a sharp increase in domestically produced fabrics, which were becoming less expensive and more widely available than imported goods. Quiltmakers experimented with complex geometry in pieced quilts and layers of intricacy in appliquéd quilts. There were solid fabrics and prints, often red, white, and green. Elaborate Baltimore Album quilts and complicated pieced designs such as Mariner's Compass were meant to impress.

The quilts of the 1840s typically had a traditional look, but the *Sprigs of Photinia Medallion* quilt from Baltimore was a surprisingly modern discovery. Its bold design is a big departure from the heavily layered Baltimore Album quilts. Even though the design is simple, the maker spared no expense with the generous use of Turkey red fabric, one of the most costly fabrics of the day. The result is a timeless medallion quilt design, with sprigs of photinia framed by concentric circles and squares.

Throughout the Victorian period and into the twentieth century, quiltmakers experimented with new materials such as silks, satins, velvets, and challis wools. Rich jewel-tone colors and dark drabs dominated the cloth foundation–pieced quilts, often made to decorate front parlors rather than beds. Crazy quilts and Log Cabins were all the rage. Patriotic quilts, fundraising quilts, and two-color quilts were also popular around the turn of the century, and by the 1930s, pastel colors and small-scale print fabrics such as those found in feed sacks were on trend.

There were many published patterns throughout the 1930s, when quiltmaking was at a peak of popularity. Grandmother's Flower Garden, Double Wedding Ring, Dresden Plate, and Sunbonnet Sue were all popular. The soft colors seen in these quilts are unmistakable. A 1930s Barn Raising Log Cabin from Ohio was made with a luscious assortment of mostly pastel fabrics. The background was all pieced with solid white, the texture defining the negative space, much like today's quilts.

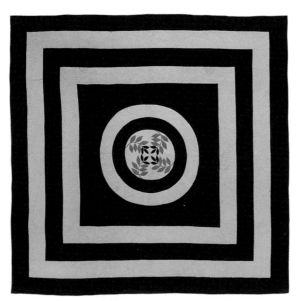

Sprigs of Photinia Medallion, cottons, unknown maker, Baltimore, c. 1840

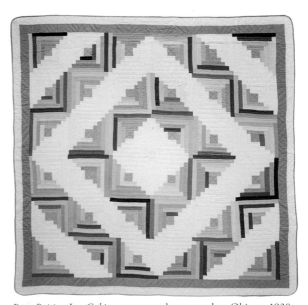

Barn Raising Log Cabin, cottons, unknown maker, Ohio, c. 1930

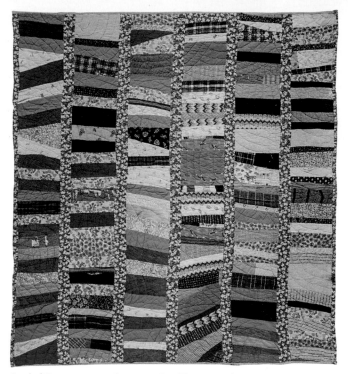

Indiana Puzzle, cottons, Sarah Nixon, Verona, New Jersey, c. 1935

Stacked Bars, cottons, unknown maker, Texas, c. 1960
Photo by Bill Volckening

A 1930s quilt made by Sarah Nixon of Verona, New Jersey, with a Monkey Wrench pattern, also makes good use of negative space. Its swirling blue and white pieced blocks alternate with solid blocks, creating a larger, interlocking secondary design. The futuristic-looking pattern goes from edge to edge with no border, another characteristic seen in today's quilts.

In the 1940s and 1950s there was a decline in quilt-making and the industry lagged. It was faster, easier, and less expensive to buy bedding at a department store. There were fewer people making quilts, but some communities such as the Amish continued the tradition. Other quiltmakers, especially throughout the South, worked in an improvisational style. A c. 1960s quilt from Texas, *Stacked Bars*, was made in that spirit. Its unevenly cut, scrappy fabrics show the maker's hand. The quilt has soul.

Colors were wild and materials mostly synthetic during the great quiltmaking revival of the 1970s. Interest in quiltmaking sharply increased with the Arts and Crafts revival, women's liberation, and the Bicentennial. Quiltmaking was an important part of women's history and art history. It was America's longest and most significant tradition of women's creative expression.

In the middle 1960s and early 1970s, a broad audience began to recognize quilts as works of art. Landmark exhibitions were hung at the Newark Museum in New Jersey ("Optical Quilts," 1965) and the Whitney Museum of American Art in New York ("Abstract Design in American Quilts," 1971). These exhibitions presented quilts in a new context, on the walls of museum galleries, promoting the idea that quilts were something more than bedding.

Modern Roots—Today's Quilts from Yesterday's Inspiration

Collectors Jonathan Holstein and Gail van der Hoof assembled the collection displayed at the Whitney in 1971. In the 1973 book *The Pieced Quilt: An American Design Tradition*, Holstein discussed the aesthetics of quilts. Modernism was a central focus, and quilts represented the modern roots of other visual media such as painting and graphic design.

"At first, having some general notion of the age of many pieced quilts I saw, I was struck by their 'modern' look in general and their visual similarities to some of the painting movements in the last several decades in particular," wrote Holstein. "As I began to establish firmer dates for these quilts, I was impressed by how anachronistic the images seemed for the eras in which they were made."

Crossroads to Bachelor Hall, cottons, unknown maker, Texas, c. 1870

In 2014, I presented a lecture at the Portland Sew-Down called "Masterpiece Quilts: Modernism in American Patchwork." The talk had an unofficial second title—"There's Something Modern About That Quilt." I showed examples of modernism throughout American quiltmaking in a timeline of quilts. Jacqueline Sava of Toronto, Canada, returned home wanting to make a new quilt inspired by a magnificent 1870s red, white, and green Crossroads quilt from Texas.

Her success in designing a new quilt (*Crossroads to Bachelor Hall*, page 39) inspired by an old one

confirmed something I was already thinking. Old quilts were rich with information and inspiration for today's quilters. They were full of ideas and knowledge found nowhere else. Quilts are America's most beloved works of art, and they keep us warm at night. This book presents twelve quilts from my collection, exploring characteristics of modernism. I hope you will enjoy the book and keep looking at old quilts. Live with them, learn from them, and love them.

—Bill Volckening

NOTES FROM THE EDITORS

When we started working with Bill on this book, we knew that that much of the charm and "soul" of these quilts comes from the way they were made, often by hand and without the use of modern tools such as rotary cutters and rulers—seams aren't always straight, points might be cut off, things don't always match up.

We leave it up to you to decide how much "soul" you want to put into your quilt. Here are some examples of antique/vintage quilts and their modern-made counterparts.

Crossroads to Bachelor Hall

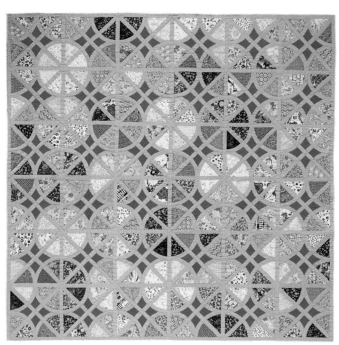

Modern-made quilt by Jacqueline Sava, 2015 (page 39)

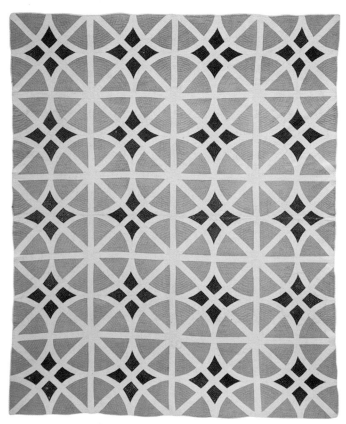

Original quilt, c. 1870 (page 32)

Stacked Bars / Bars

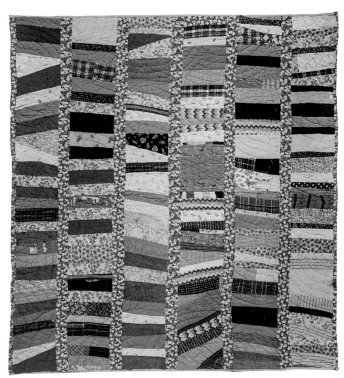

Original quilt, c. 1960 (page 96)

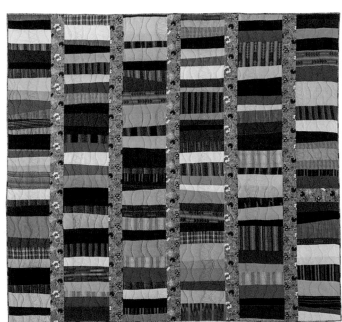

Modern-made quilt by Krista Hennebury, 2015 (page 101)

Airplanes / Missing Man Memorial

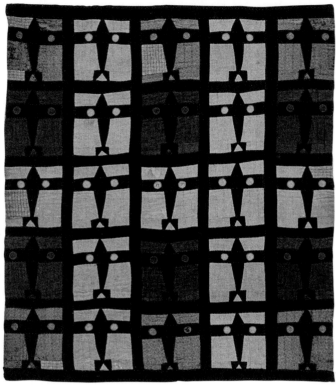

Original quilt, 1937 (page 86)

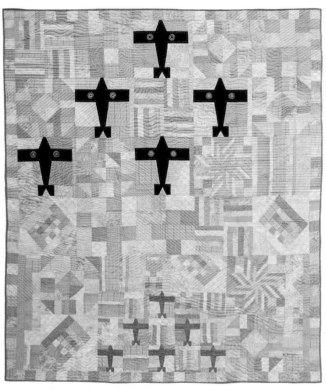

Modern-made quilt by Christine Turner, 2015 (page 95)

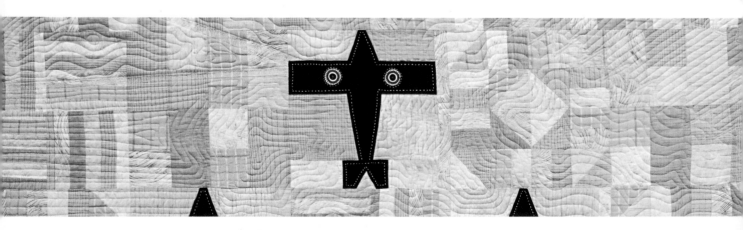

Modern Roots—Today's Quilts from Yesterday's Inspiration

Shadow Box

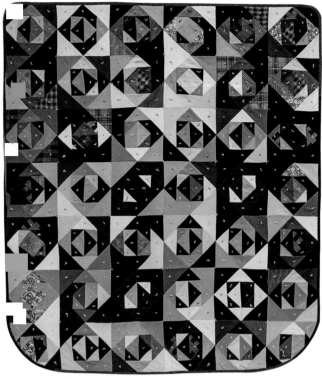

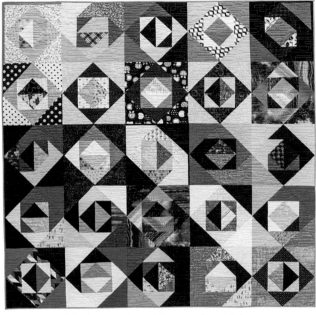

Modern-made quilt by members of the
Portland Modern Quilt Guild, 2015 (page 109)

Original quilt, c. 1970 (page 102)

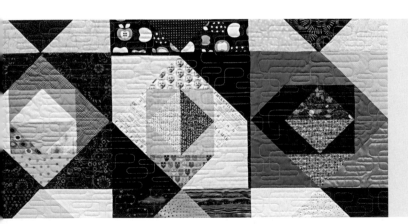

Appliqué Notes

For quilts with appliqué, use the method of your choice—turned-edge, raw-edge, or fusible. The appliqué patterns are presented with no seam or turn-under allowance; add as appropriate. Reverse designs as needed for fusible appliqué.

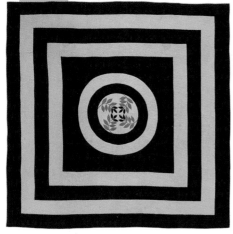

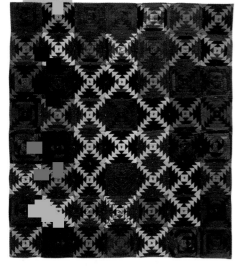

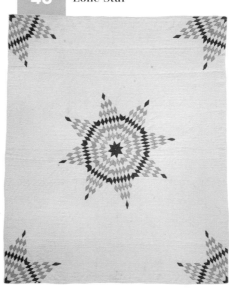

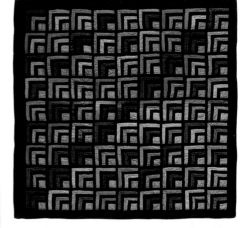

62 Radiating Fans

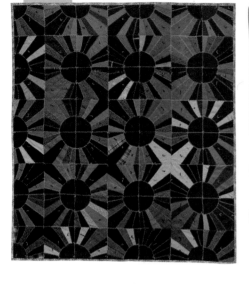

70 Barn Raising Log Cabin

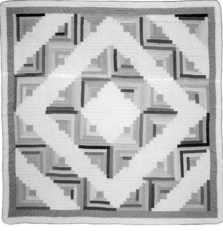

78 Indiana Puzzle

86 Airplanes

96 Stacked Bars

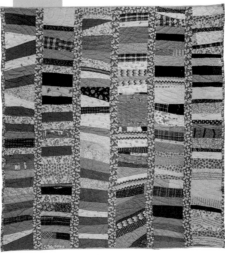

102 Shadow Box

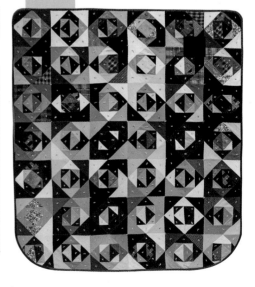

Sprigs of Photinia Medallion

FINISHED QUILT: 97½" × 97½"

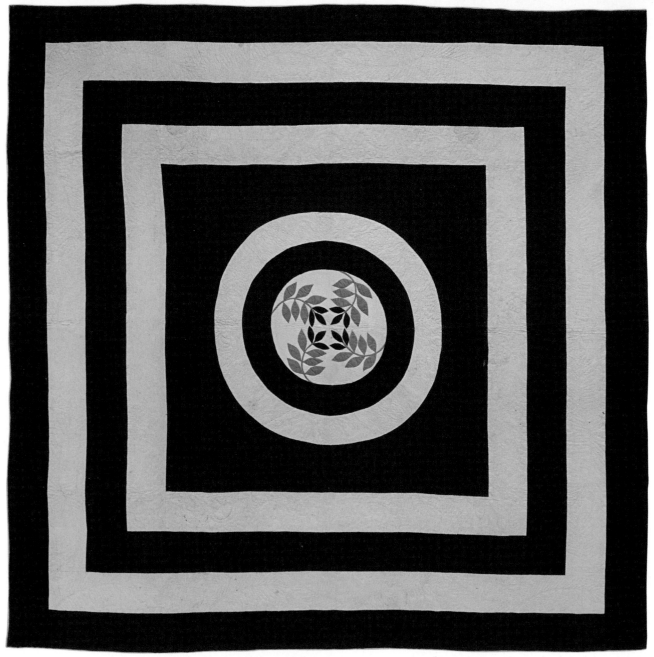

Made from cottons by an unknown maker; Baltimore, Maryland; c. 1840

Minimalism is a hallmark of modern design. This stunning 1840s medallion quilt has a surprisingly minimal overall pattern, a bull's-eye framed by squares. The fabrics are all solids: Turkey Red, overdyed green, and off-white or cream. Four gently curved photinia branches fill the circular center panel.

In the 1840s, American-made fabrics began to take the place of imported fabrics, and the greater availability of more reasonably priced goods led to a period of innovation in patchwork quilt-making. Complex designs such as Mariner's Compass emerged, and occasionally some simple designs such as the Sprigs of Photinia medallion.

No maker's information remained with the quilt, but it would be safe to say it came from an affluent family. The amount of Turkey red fabric is remarkable considering it was among the most expensive fabrics in the mid-nineteenth century. The process of dyeing the colorfast crimson fabric, which originated in Turkey and the Middle East, was complicated and involved many steps. Since the process was so laborious, the fabric was expensive.

Photinia branches with red tips appear in many quilts of the period, especially in the exquisite, elaborately appliquéd album quilts made in Baltimore and the vicinity. Usually the motif includes straight branches forming an X shape—it is very uncommon to see a formation with curved branches.

Construction Notes

The original quilt has borders that vary between 6" and 6¾" wide. For consistency, the pattern has borders that are all 6" wide. The rings and squares are pieced as in the original. The quilt was initially finished with the pillowcase method; however, at some point, three sides were folded over to the front ¼" and hand stitched in place. The instructions that follow include traditional binding.

Even though the overall design is minimal and modern looking, the hand quilting is of the period. Well-planned and masterfully executed, the quilting designs include a diamond grid in the red with double-row botanical motifs in the off-white, and outline quilting with rows of echo fill surrounding the branches in the central circle. The appliqué is not quilted, giving it a slightly three-dimensional effect.

Today's quiltmakers would do almost anything to avoid visible marking lines on a finished quilt. With antique quilts, it is thrilling to see pencil markings under the rows of quilting. Pencil markings indicate minimal washing, an important factor when assessing condition. It is lovely to see the hand of the maker in the pencil lines as well as the stitching.

Fine finishing is expected in quilts of the period. The quilt is large, thin, and crisp, similar to other masterpiece examples of the period. The quilt's elegant sense of minimalism is surprising. The minimal design perfectly frames the delicate appliqué, and the quilt is refreshingly modern for an object made 175 years ago.

Red, white, and green quilts were very popular in the mid-nineteenth century, but today the combination of colors is reminiscent of the Christmas holidays. Using another color in place of the large pieces of red fabric would be an easy update to an already modern-looking design.

Materials

Yardage requirements are based on 40"-wide fabric.

Cream: 5⅛ yards for center circle, second ring, and first and third borders; or 4½ yards if borders are pieced from width-of-fabric strips

Red: 7⅜ yards for first ring, center square, second and final borders, and leaves; or 6 yards if borders are pieced from width-of-fabric strips

Green: ¼ yard for stems and leaves

Binding: ⅝ yard to make ¼" finished double-fold binding

Backing: 105" × 105"

Batting: 105" × 105"

Cutting

Make templates of quarter-circle and leaves A, B, and C, using Sprigs of Photinia Medallion patterns (pullout page P1).

Cream

- Cut 2 strips 17¾" × width of fabric; subcut into 4 squares 17¾" × 17¾" for second ring.

- Cut 1 strip 49½" × width of fabric; subcut 2 strips 6½" × 49½" for first top and bottom border and 1 square 22" × 22" for center circle.

- Cut 2 strips 6½" × 85½" lengthwise for third side border.

- Cut 2 strips 6½" × 73½" lengthwise for third top and bottom border.

- Cut 2 strips 6½" × 61½" lengthwise for first side border.

or

If you are piecing the borders, cut 14 strips 6½" × width of fabric. Piece the strips end to end and then cut the 4 sets of borders as noted above.

Red

- Cut 4 strips 25" × width of fabric; subcut into 4 squares 25" × 25" for center square, and 4 squares 13½" × 13½" for first ring. From remaining 25" strips, cut 12 of leaf A, adding your preferred seam allowance and flipping template as desired.

- Cut 2 strips 6½" × 97½" lengthwise for final border.

- Cut 2 strips 6½" × 85½" lengthwise for final border.

- Cut 2 strips 6½" × 73½" lengthwise for second border.

- Cut 2 strips 6½" × 61½" lengthwise for second border.

or

If you are piecing borders, cut 17 strips 6½" × width of fabric. Piece the strips end to end and then cut the 4 sets of borders as noted above.

Green

- Cut 8 of leaf B and 16 of leaf C, adding your preferred seam allowance and flipping templates as desired.

- Cut 4 stems on the bias 1" × 9".

Binding

- Cut 11 strips 1⅝" × width of fabric.

Construction

Sew all seams with a ¼″ seam allowance unless otherwise noted.

Appliqué the Center Circle

1. Fold the 22″ × 22″ square in half and lightly crease the fold. Fold it in half the opposite direction and crease again. Unfold the square.

2. Use the 18″ quarter-circle pattern (pullout page P2) to mark or baste an 18″ circle in the center of the 22″ square.

3. Place the stem and leaf appliqués in each quarter of the circle, referring to the appliqué placement guide (pullout page P1). Keep appliqués ½″ inside the edge of the circle and note that an inner leaf crosses the quarter-crease. Appliqué using your favorite method.

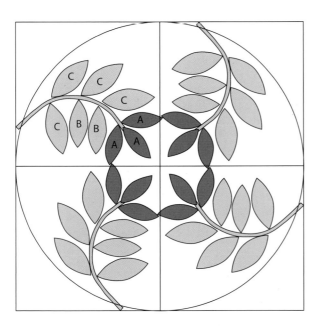

4. Trim the square to an 18″ circle.

TIP

How to Draw a Circle with Cardboard, a Pushpin, and a Pencil

If you don't want to use the provided quarter-circle pattern and would prefer to draw the complete circle yourself, follow the directions below.

1. Cut a 1″-wide strip of thin cardboard at least 2″ longer than the radius of the circle. For an 18″ circle, the radius is 9″, so cut the cardboard 11″ long.

2. Mark the cardboard 1″ from the end, and then measure 9″ from this mark, and mark again.

3. Use the pushpin to make a hole exactly on each marked line in the center of the cardboard.

4. Put the pushpin in one hole and place it in the center of the square.

5. Put the pencil tip (a mechanical pencil is easiest) in the other hole.

6. Holding the pushpin in place, draw the circle.

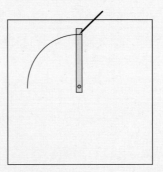

Assemble the Center Rings

Press all the seams to the side.

1. Sew 2 red 13½″ × 13½″ squares together and press.

2. Repeat for the second set of squares.

3. Sew the 2 sets together into a large square and press.

4. Place the appliquéd circle onto the square from Step 3, matching the quarter marks on the circle to the seams in the square.

5. Sew the circle to the square with your favorite method.

6. Measure, mark, and cut a 26½″-diameter circle centered in the square from Step 5.

7. Repeat Steps 1–3 with the 4 cream 17¾″ × 17¾″ squares.

8. Place the circle from Step 6 onto the square from Step 7, shifting the circle one-eighth of a turn to place the seams between those of the square.

9. Repeat Step 5.

10. Repeat Steps 1–3 with the 4 red 25″ × 25″ squares.

11. Measure, mark, and cut a 34″ circle centered in the square.

12. Place the circle from Step 11 onto the square from Step 10, shifting the circle to place the seams of the red circle in line with the seams of the square.

13. Repeat Step 5.

Add the Borders

Press all the seams toward the darker fabric.

1. Sew the 49½″-long cream borders to the top and bottom.

2. Sew the 61½″-long cream borders to the sides.

3. Repeat Steps 1 and 2 to add the 3 remaining borders.

Finishing

To Finish Using the Pillowcase Method

1. Layer the quilt top on the batting and place the backing right side down on top of the quilt top. Pin around the edges.

2. Stitch around the edges using a ¼″ seam allowance, leaving a 12″ opening to turn right side out.

3. Turn the quilt right side out and carefully press the edges.

4. Hand stitch the opening closed.

5. Quilt as desired.

To Finish with Binding

1. Layer the quilt top, batting, and backing.

2. Baste using your preferred method.

3. Quilt as desired.

4. Bind the quilt using your preferred method.

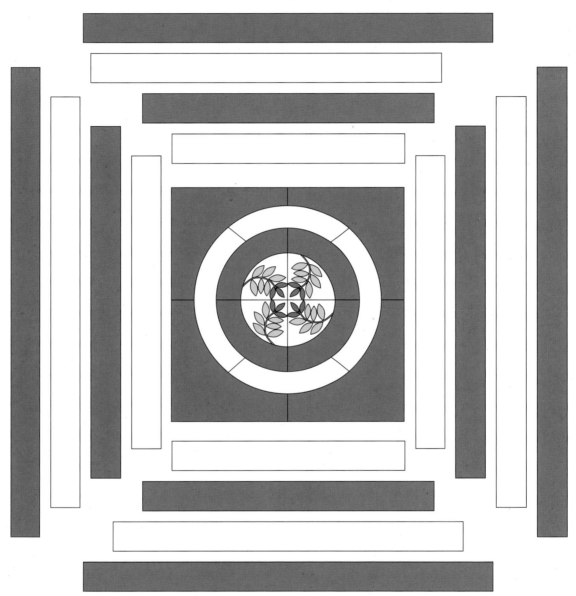

Quilt assembly

Sprigs of Photinia Medallion
Smaller Version

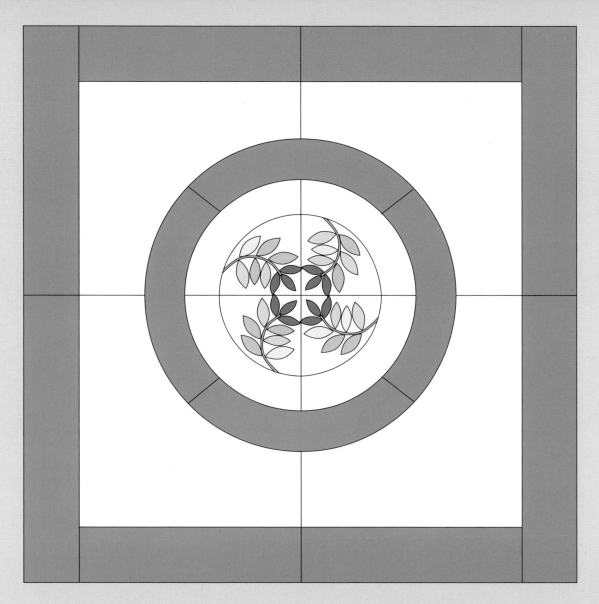

Omit the outer 3 borders to create a smaller version that is 61½″ × 61½″.

Materials

Yardage requirements are based on 40"-wide fabric.

Blue: 3½ yards for center circle, second ring, and borders

White: 3 yards for first ring and center square

Various greens: approximately ¼ yard total for stems and leaves

Red: ⅛ yard for leaves

Binding: ⅜ yard to make ¼" finished double-fold binding

Backing: 69" × 69"

Batting: 69" × 69"

Cutting

Make templates for quarter-circle and leaves A, B, and C, using Sprigs of Photinia Medallion patterns (pullout pages P1 and P2).

Blue

- Cut 1 square 22" × 22" for center circle.

- Cut 2 strips 17¾" × width of fabric; subcut into 4 squares 17¾" × 17¾" for second ring.

- Cut 2 strips 6½" × 61½" lengthwise for first border.

- Cut 2 strips 6½" × 49½" lengthwise for first border.

White

- Cut 4 strips 25" × width of fabric; subcut into 4 squares 25" × 25" for center square, and 4 squares 13½" × 13½" for first ring.

Various greens

- Cut 8 of leaf B and 16 of leaf C, adding your preferred seam allowance and flipping templates as desired.

- Cut 4 stems on the bias 1" × 9".

Red

- Cut 12 of leaf A, adding your preferred seam allowance and flipping template as desired.

Binding

- Cut 7 strips 1⅝" × width of fabric.

Refer to Construction (page 17) to make the quilt.

Tennessee Pieced Quilt

FINISHED QUILT: 66" × 74½"

FINISHED BLOCKS: 17" × 17" and 8½" × 17" (9 blocks, 3 × 3 setting)

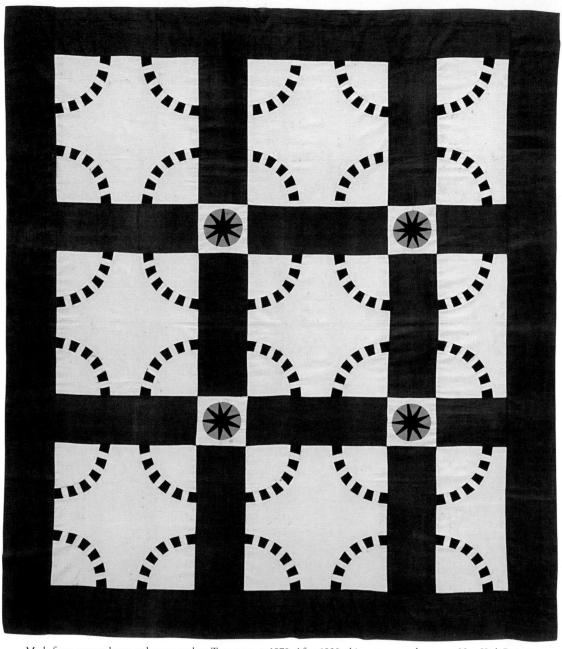

Made from cottons by an unknown maker; Tennessee; c. 1870. After 1930, this pattern was known as New York Beauty.

Around the time this c. 1870s quilt top from Tennessee was made, the American cotton industry was getting back on track following the Civil War. In *Dating Fabrics: A Color Guide 1800–1960*, Eileen Trestain wrote that the Civil War "had a great effect on the history of textiles in America, especially because Southern plantations were no longer able to produce the amount of cotton required to supply the country."

The patchwork design known today as New York Beauty is among the most intricate, but the maker of this modern-looking quilt top had a much more simplified interpretation. It is made with patriotic red, white, and blue fabrics with pops of cheddar orange, all thin cottons. It is hand pieced, with blocks that include chunky dotted lines rather than sunbursts with many sharp points.

New York Beauty quilts commonly have thousands of pieces, but this top has fewer than 500. The most complex elements in the top are the nine-pointed red sunburst cornerstones pieced with

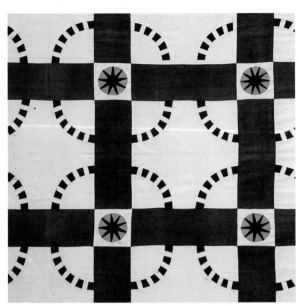

Construction Notes

The original quilt was never finished; it is only a top, and it is meticulously pieced. If you wish to duplicate the original design, note that the three arcs in the top center block are pieced opposite of the others, with six white pieces and five red pieces. Adjust the fabric cutting as needed.

orange and white in the background. Each of these cornerstones is constructed with a total of 23 pieces. Still, they are much less intricate than other period examples.

Aniline dyes were in development at the time, but there were still many fabrics with unstable dyes. The blue fabric appears to have some color loss, and in a certain light the fabric looks almost green. The top includes six complete blocks with three half-blocks to the right-hand side. There are just four cornerstones, and the sashing is solid fabric rather than pieced points radiating from a central strip.

Quiltmakers were innovators in design. The unidentified maker of this quilt top had an original idea based on a much more complex, traditional motif. The result is a surprisingly modern-looking quilt top from the early post–Civil War period. A twenty-first-century interpretation could easily be made in a variety of fabrics including modern solids, and the amount of negative space would allow for creative quilting.

Materials

Yardage requirements are based on 40"-wide fabric.

White: 2½ yards for blocks, arc pieces, and cornerstone background

Red: ⅝ yard for arc pieces and cornerstone stars

Orange: ¼ yard for cornerstone stars

Green: 2½ yards for sashing and border

Binding: ½ yard to make ¼" finished double-fold binding

Backing: 74" × 82"

Batting: 74" × 82"

Foundation piecing paper: such as Carol Doak's Foundation Paper (by C&T Publishing)

Cutting

Make templates for cornerstone circle, star circle, corner A, and corner B using Tennessee Pieced Quilt patterns (pullout page P1).

White

- Cut 4 strips 17½" × width of fabric; subcut 6 squares 17½" × 17½", 3 rectangles 17½" × 9", and 150 rectangles 1¾" × 1⅜" for arcs.

- Cut 1 strip 7" × width of fabric; subcut 4 squares 7" × 7" for cornerstones.

Red

- Cut 1 strip 2¼" × width of fabric; subcut 36 rectangles 2¼" × 1" for stars.

- Cut 8 strips 1¾" × width of fabric; subcut 180 squares 1¾" × 1¾" for arcs.

- Cut 4 circles using star circle pattern.

Orange

- Cut 2 strips 2¼" × width of fabric; subcut 36 rectangles 2¼" × 2" for stars.

Green

- Cut 13 strips 6¼" × width of fabric; subcut 6 strips into 10 rectangles 6¼" × 17½" and 2 rectangles 6¼" × 9".

- Sew all remaining strips together end to end; subcut into 2 border strips 6¼" × 66" and 2 border strips 6¼" × 63".

Binding

- Cut 8 strips 1⅝" × width of fabric.

Modern Roots—Today's Quilts from Yesterday's Inspiration

Construction

Sew all seams with a ¼″ seam allowance unless otherwise noted.

Block Assembly

Press the seams to the side unless otherwise noted.

Make 30 copies of the arc foundation pattern and 4 copies of the star foundation pattern (pullout page P1) on foundation piecing paper.

Sewing the Arcs

1. Beginning at Wedge 1 on an arc foundation, place a red square right side up on the unprinted side, making sure it covers the lines on the foundation so as to have at least a ¼″ seam allowance all around. Pin in place.

2. Place a white rectangle right side down on the red square. Adjust the placement so that when sewn it will cover Wedge 2 with at least a ¼″ seam allowance all around. Pin it in place.

3. On the printed side of the foundation, stitch along the line between Wedges 1 and 2. Fold the white piece on the seamline and check that it fully covers Wedge 2.

4. Fold the paper back along the stitching line and trim the seam to ¼″.

5. Continue to add pieces in numerical order, alternating red and white to finish the arc.

6. After all 11 wedges are sewn, press carefully and trim all edges on the ¼″ seamline.

7. Repeat Steps 1–6 to make 30 arcs.

Adding Arcs to Squares

1. Place Corner Template A on a corner of a 17½″ × 17½″ square, and mark the quarter-circle.

2. Carefully cut exactly along the marked line to cut the corner from the square.

3. Place Corner Template B on the quarter-circle you cut away from the square, and mark the smaller quarter-circle.

4. Carefully cut exactly along the marked line. Set aside the quarter-circle and discard the remaining arc.

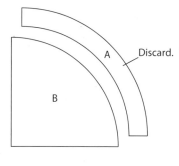

5. Repeat Steps 1–4 to cut away the other 3 corners of the background square.

6. Fold a pieced arc in half, wrong sides together, and finger-press a crease at the center of the center wedge.

7. Fold a quarter-circle from Step 4 in half, right sides together, and finger-press a crease on the round edge.

8. Place the pieced arc and the quarter-circle right sides together, matching the center creases, and pin. Align and pin both ends, then continue to pin the 2 curves together.

9. Sew the pieced arc to a quarter-circle, with the quarter-circle on the bottom and the arc on the top. Press the seam away from the quarter-circle.

10. Repeat Steps 6–9 to complete 3 more quarter-circles.

11. Fold the background piece from Step 5 in half diagonally and finger-press a crease along the center line of the curved edges. Fold again in the opposite direction and crease again in the same manner.

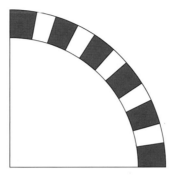

12. Place the background piece and a corner/arc piece right sides together, matching the center creases, and pin. Align and pin both ends, then continue to pin the 2 curves together in the same manner as Step 8.

13. Sew the background piece and the corner/arc piece, with the corner/arc piece on the bottom. Press the seam away from the quarter-circle.

14. Repeat Steps 11–13 to add 3 more quarter-circles to the background to complete the block.

15. Repeat Steps 1–14 to complete 6 full blocks and 3 half-blocks.

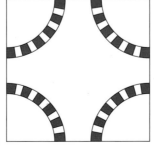

Cornerstone Assembly

1. Cut each star foundation along the bold line, opening the ring and removing the center.

2. Beginning at Wedge 1 on a cornerstone star foundation, place a red rectangle right side up on the unprinted side, making sure it covers the lines on the foundation so as to have at least a ¼″ seam allowance all around.

3. Place an orange rectangle right side down on the red rectangle, adjusting the placement so that when sewn it will cover Wedge 2 with a ¼″ seam allowance all around.

4. On the printed side of the foundation, stitch along the line between Wedges 1 and 2. Fold the orange piece over and check that it fully covers Wedge 2.

5. Fold the paper back along the stitching line and trim the seam to ¼″.

6. Continue to add pieces in numerical order, alternating red and orange rectangles, to finish the star.

7. After all 18 wedges are sewn, press carefully.

8. Trim along the outer ¼″ seamline, making sure to leave a ¼″ seam allowance on the red Wedge 1 and the orange Wedge 18. Trim away center of circle along the seamline.

Leave ¼″ seam allowance.

9. Fold the foundation pieced unit so that Wedges 1 and 18 are right sides together, matching the cut foundation edges. Pin and sew together along the foundation edge. Press the seam to the side.

10. Repeat Steps 1–9 (page 27) to make 4 stars.

11. Appliqué a star circle to the center of each star.

12. Using the cornerstone circle template, cut a circle from the center of each 7″ × 7″ square.

13. Center the circle in the square over a star and reverse appliqué the circle to the star using your favorite method.

14. Trim each cornerstone to a 6¼″ × 6¼″ square.

15. Remove the foundation paper from stars.

Quilt Assembly

1. Arrange the blocks in a 3 × 3 grid, with the half-blocks in the third column and the cornerstones at the intersections.

2. Sew the 6¼″ × 17½″ sashing strips between the blocks in each block row. Press the seams toward the sashing.

3. Sew the 6¼″ × 17½″ sashing strips to the left side of each cornerstone. Press the seams toward the sashing.

4. Sew each pair of the Step 3 units together.

5. Sew the 6¼″ × 9″ sashing strips to the last cornerstone in each row. Press the seams toward the sashing.

6. Sew the rows of blocks and cornerstones together, matching seams.

7. Sew the side borders to the quilt. Press the seams toward the borders.

8. Sew the top and bottom borders to the quilt. Press the seams toward the borders.

9. Remove the foundation paper from the arcs.

Finishing

1. Layer the quilt top, batting, and backing.

2. Baste using your preferred method.

3. Quilt as desired.

4. Bind the quilt using your preferred method.

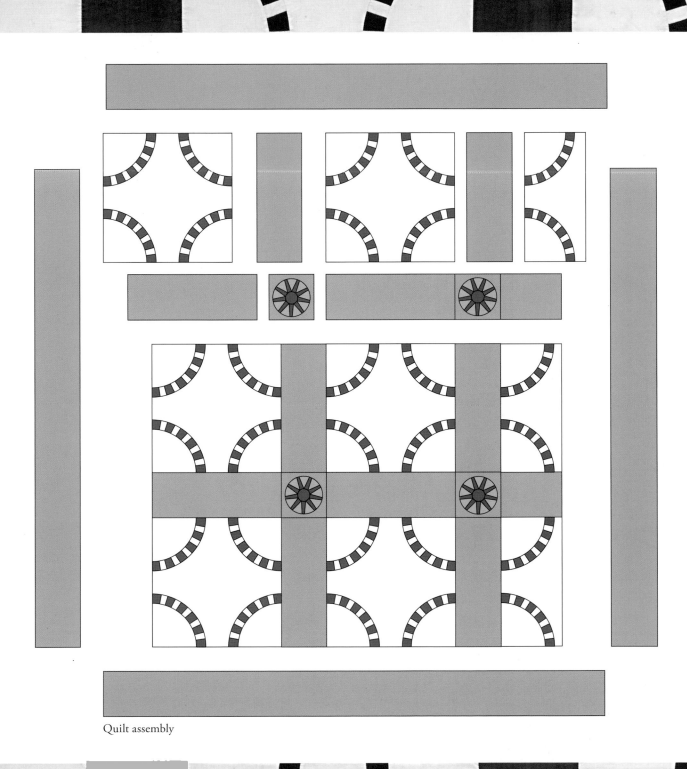

Quilt assembly

Make 4 blocks to create a smaller version that is 51¾″ × 51¾″.

Materials

Blue: 1¼ yards for block and cornerstone background

Orange: ⅜ yard for arc pieces

Yellow: ⅛ yard for cornerstone star

White: 1⅝ yards for sashing and border

Binding: ⅜ yard to make ¼" finished double-fold binding

Backing: 60" × 60"

Batting: 60" × 60"

Cutting

Make templates for cornerstone circle, star circle, corner A, and corner B using Tennessee Pieced Quilt patterns (pullout page P1).

Blue

• Cut 2 strips 17½" × width of fabric; subcut 4 squares 17½" × 17½".

• Cut 1 strip 2¼" × width of fabric; subcut 9 rectangles 2¼" × 2" for star.

Orange

• Cut 5 strips 1¾" × width of fabric; subcut 96 squares 1¾" × 1¾" for arcs.

Yellow

• Cut 1 strip 2¼" × width of fabric; subcut 9 rectangles 2¼" × 1" for star and 1 circle using star circle pattern.

White

• Cut 1 strip 7" × width of fabric; subcut 1 square 7" × 7"; subcut remaining rectangle into 5 strips 1⅜" × 33"; subcut 80 rectangles 1⅜" × 1¾" for arcs.

• Cut 7 strips 6¼" × width of fabric; subcut 2 strips into 4 rectangles 6¼" × 17½".

• Sew remaining 5 strips together end to end; subcut into 2 border strips 6¼" × 51¾" and 2 border strips 6¼" × 40¼".

Binding

• Cut 6 strips 1⅝" × width of fabric.

Refer to Construction (page 25) to make the quilt.

Made from cottons by an unknown maker; Texas; c. 1870

Red, white, and green quilts were especially popular around the 1850s and 1860s, but this 1870s Crossroads quilt from Texas uses the colors in a fresh way. The fabrics are all solids—lime green, Turkey red, and white—and the rarely seen patchwork design looks like something out of a twenty-first-century pattern book.

Many of the pattern names considered to be the traditional names today were the result of mass media involvement with the publication of quilt patterns around the turn of the twentieth century and later. This pattern got its name from a design called Cross Roads to Bachelor's Hall, published by Clara Stone in 1906. Similar designs, such as Wagon Wheels by the *Kansas City Star*, were published through the 1940s.

Before published patterns, quilt designs were commonly referred to as patchwork. Some makers may have assigned names and special meanings to the patterns, but there is no good way to determine

those details in quilts made by unknown makers. Even without any of its family history, though, this quilt has a lot to say.

Each block includes eight green pie-shaped wedges placed equally in sets of two in each of the four corners. Strips of white fabric divide the green wedges and the cluster of four red diamond-shaped patches at the center of the block. When the blocks are placed side by side, a secondary circular pattern is created. The lime green circles are reminiscent of slices of limes, and the clusters of red diamonds form four-pointed stars in the negative space.

A search for similar quilts made in the period yielded very few results. Two quilts from Tennessee made in the 1880s and later appeared in a search of the Quilt Index, an online database with more than 50,000 records of documented quilts. A few later, scrappy examples from various places also came up in the search. So, despite being a very dynamic design, it was not made often.

Construction Notes

This quilt will be a bit more challenging to make because of the curved piecing, but it will be worth it. Thanks to Jacqueline Sava for confirming the construction methods of this quilt.

Materials

Yardage requirements are based on 40"-wide fabric.

Green: 4½ yards for Pie A

White: 4¾ yards for Arc B and all strips and sashing

Red: 1 yard for Diamond C

White: ½ yard to make ¼" finished double-fold binding

Backing: 85" × 104"

Batting: 85" × 104"

Cutting

Make templates A, B, and C using Crossroads to Bachelor Hall patterns (pullout pages P1 and P2). All patterns include a ¼" seam allowance.

Green

- Cut 16 strips 9" × width of fabric; subcut 160 Pie Piece A.

White

- Cut 11 strips 7" × width of fabric; subcut 160 Arc B.

- Cut 43 strips 2" × width of fabric; subcut 20 strips 2" × 27", 40 strips 2" × 13", and 15 strips 2" × 18½". Sew 8 strips together end to end and cut into 4 strips 2" × 77".

Red

- Cut 8 strips 4" × width of fabric; subcut 80 Diamond C.

Binding

- Cut 10 strips 1⅝" × width of fabric.

Construction

Sew all seams with a ¼" seam allowance unless otherwise noted.

Block Assembly

Press the seams to the side.

1. Fold a Pie Piece A and an Arc B in half along the curve and finger-press a crease.

2. Place A and B right sides together, match the ends and half-points, and pin the pieces together.

3. It will be easier to sew with A on the bottom and B on the top. Press the seam toward B. Repeat to make 160 units.

4. Align a unit from Step 3 to the left side of a Diamond C, matching marks, and pin. Sew the diamond to the unit. Press the seam away from the diamond.

5. Align another unit from Step 3 to the right-hand side of the diamond, matching marks, and pin. Sew the unit to the diamond. Press the seam away from the diamond.

6. Place lower segments of both arcs right sides together and pin. Mark a seamline

from the point of the diamond to the end of the arcs, ½″ from the edge at the end. Stitch the arcs together along this line. Check that the unit lies flat and the 2 arcs together measure 1⅜″ wide at the end. Trim the seam and press open.

7. Repeat Steps 4–6 to make 80 quarter-blocks.

8. Place a 13″-long sashing piece along the right-hand side of a quarter-block, right sides together and matching the end of the sashing with the 90° corner. (The other end will extend slightly past the 45° point. This is for trimming later.) Press the seam toward the sashing.

9. Sew a second quarter-block to the other side of the sashing and press, making a half-block. Press the seam toward the sashing.

10. Repeat Steps 8 and 9 to make 40 half-blocks.

11. Center a 27"-long sashing piece along the long diagonal side of a half-block, right sides together. (The ends will extend slightly past the 45° points. This is for trimming later.) Pin and sew together. Press seam toward the sashing.

12. Sew a second half-block to the other side of the sashing and press the seam toward the sashing.

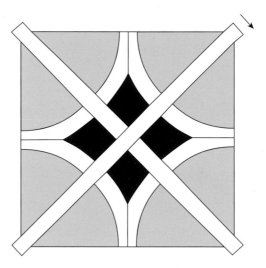

13. Trim each corner of the block to a 90° point, keeping the point centered in the sashing.

14. Repeat Steps 11–13 to make 20 blocks.

Quilt Assembly

1. Arrange the blocks in a 4 × 5 grid.

2. Sew the 18½"-long sashing strips between the blocks in each column, pressing all seams toward the sashing.

3. Sew the 77"-long sashing strips between the columns.

Finishing

1. Layer the quilt top, batting, and backing.

2. Baste using your preferred method.

3. Quilt as desired.

4. Bind the quilt using your preferred method.

Quilt assembly

Crossroads to Bachelor Hall
Smaller Version

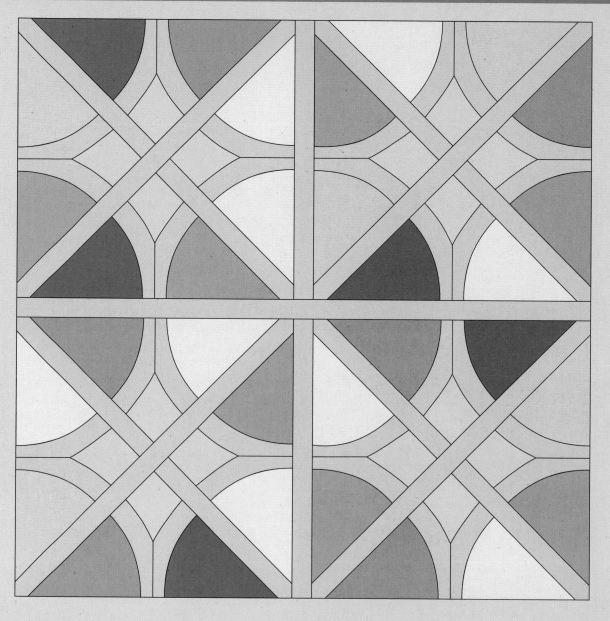

Make 4 blocks to create a smaller version that is 38″ × 38″.

Materials

Various pinks and oranges: ¼ yard each of 6 shades for Pie Piece A

Gray: 1⅛ yard for Arc B and all strips and sashing

Blue: ⅜ yard for Diamond C

White or alternative: ⅜ yard to make ¼" finished double-fold binding

Backing: 46" × 46"

Batting: 46" × 46"

Cutting

Make templates A, B, and C using Crossroads to Bachelor Hall patterns (pullout pages P1 and P2). All patterns include a ¼" seam allowance.

Pink/Orange

- Cut 5 or 6 Pie Piece A pieces from each fabric, for a total of 32.

Gray

- Cut 3 strips 7" × width of fabric; subcut 32 Arc B pieces.

- Cut 8 strips 2" × width of fabric; subcut 1 rectangle 2" × 38", 4 rectangles 2" × 27", 2 rectangles 2" × 18½", and 8 rectangles 2" × 13".

Blue

- Cut 2 strips 4" × width of fabric; subcut 16 Diamond C pieces.

Binding

- Cut 5 strips 1⅝" × width of fabric.

Refer to Construction (page 34) to make the quilt.

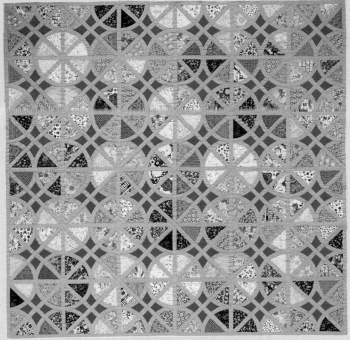

Crossroads to Bachelor Hall by Jacqueline Sava, 115" × 115", 2015

After seeing the original quilt during Bill Volckening's lecture at the Portland SewDown in 2014, Jacqueline was inspired. Her thoughts were "Simplicity. Strong diagonals. Complexity of form. These are the words that came to mind when I first saw this quilt. Where's the block? Is it square, circle, set on the diagonal?" She returned home and began making her quilt, using an assortment of Liberty of London Tana Lawn cottons and quilting cottons, as well as Robert Kaufman Interweave Chambray in Camel for the sashing and Kona Cotton Solids in Carrot.

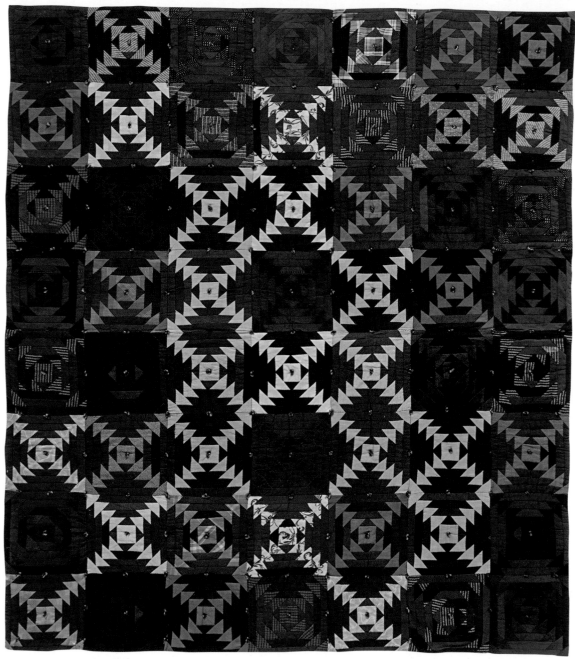

Made from wools and velvets by an unknown maker; eastern United States; c. 1890

og Cabin quilts first appeared in the third quarter of the nineteenth century, and they were among the few types of quilts made with foundation piecing. Crazy quilts and later string quilts also used foundations. These quilts were traditionally made with patches stitched directly to the foundation fabric, but sometimes paper was used. Hexagon quilts used paper foundations more often than fabric. The method of wrapping and stitching the top fabric around a hexagon-shaped paper template is known as English paper piecing.

Although English paper piecing hinted at the use of paper as a foundation in precision-pieced quilts, the movement toward paper piecing occurred much later, toward the end of the twentieth century. Materials commonly seen in late-nineteenth-century Log Cabin quilts could explain why paper piecing was not commonly used in these designs. The material was often challis wool or men's suit material, much heavier than quilting cotton, and a fabric foundation worked better with the sturdy top fabrics.

There were many variants of the Log Cabin design, and Pineapple Log Cabin was one. Log Cabins

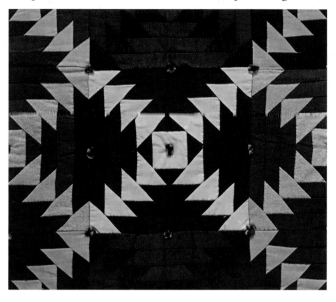

typically included strips of equal width pieced together at 90° angles to form blocks, which were then pieced together to form a multitude of larger patterns. The Pineapple Log Cabin block includes strips pieced together at an angle, with sharp points at the edges of the strips. A secondary design, similar to windmill blades in motion, appears in a lot of these quilts.

This Pineapple Log Cabin is one of the more unusual variants. Rows of isosceles triangles at the intersecting points of the adjoining strips create an X in each block. In other designs, the rows of triangles might be called Flying Geese. When the blocks are pieced together, an allover diagonal lattice design similar to an Irish Chain is established. Contrast is key; mostly bright and light fabrics are used in the rows of triangles, and low-volume darks are used in the strip-pieced background.

Using the paper-piecing method with today's quilting cottons makes this quilt much less of a challenge than when it was originally made. It would not take much to update this modern-looking geometric design—the possibilities are infinite.

Construction Notes

This is a striking example of a Pineapple block, made with a variety of midweight suiting fabrics. The background logs are a variety of dark greens; the brighter triangles are in shades of red, gold, tan, green, peach, blue, purple, and white, and some plaids, prints, and stripes. The original quilt has a pillowcase finish. Instructions that follow include both the pillowcase finish and traditional binding.

Materials

Yardage requirements are based on 40"-wide fabric.

Several dark fabrics: 7 yards total
(or 28 fat quarters) for block background

Several bright fabrics: 3½ yards total
(or 14 fat quarters) for center and arrows

Dark fabric: ½ yard to make ¼" finished
double-fold binding

Yarn for tying quilt: (optional)

Backing: 78" × 88"

Batting: 78" × 88"

Cutting

Dark fabric

For each block:

• Cut 1 strip 2¼" × width of fabric; subcut
2 squares 2¼" × 2¼" and cut each square in
half diagonally once (B); from the remaining
strip cut 4 rectangles 1½" × 8½" (F).

• Cut 2 strips 1½" × width of fabric; subcut
4 rectangles 1½" × 6½" (E) and 4 rectangles
1½" × 4½" (D).

Bright fabric

For each block:

• Cut 1 strip 2⅞" × width of fabric; subcut
8 squares 2⅞" × 2⅞" and cut each square in
half diagonally once (C), and cut 1 square
2½" × 2½" (A).

Binding

• Cut 9 strips 1⅝" × width of fabric.

Construction

*Sew all seams with a ¼" seam allowance unless
otherwise noted.*

Block Assembly

*Make 56 copies of the Pineapple Log Cabin foundation
pattern (pullout page P2). This pattern is 10½" × 10½".
If you cannot make copies larger than 8", trim the
pattern at the E/F seamline and follow the directions
in Steps 13 and 14 (page 44) to complete the block.*

1. On the unprinted
side of a founda-
tion, place and pin
the A square right
side up, making
sure there is about a
¼" seam allowance
on all sides.

2. Place and pin a
B triangle right
sides together on an
edge of A, testing
that when sewn, it
will then cover the
B space on the
foundation with
at least ¼" seam
allowances.

3. On the printed side, sew along the seamline between A and B, stitching A and B to the paper.

4. Press B away from A.

5. Repeat to add remaining B triangles.

6. Repeat Steps 2–4 to add 4 C triangles.

7. Place and pin a D rectangle along the raw edges of 2 C triangles, testing that when sewn, it will then cover the D space on the foundation with at least ¼″ seam allowances.

8. Sew along the seamline between C and D. Press D away from C.

9. Repeat Steps 6 and 7 to add 4 D rectangles.

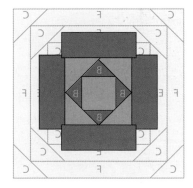

10. Fold back the foundation paper at the corner C seamline and trim the D rectangles to ¼″ beyond the seamline.

11. Repeat for all corners.

12. Repeat Steps 6–11 (page 43) to add C triangles and E and F rectangles, ending with the C triangles.

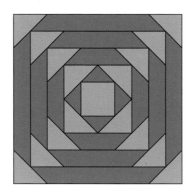

13. If your foundation square is only 8″, to complete the block, pin the F rectangles to each side of the square and stitch with a ¼″ seam allowance. Press away from E.

14. Pin the C triangles across the 4 corners, parallel to the previous C triangles and with the ¼″ seamline meeting the tip of the previous triangle. Sew the triangles and press away from the center.

15. Repeat Steps 1–14 to make 56 blocks.

Quilt Assembly

1. Arrange the blocks in a 7 × 8 grid.

2. Sew 7 blocks together to complete each row.

3. Sew the 8 rows together.

4. Remove the foundation paper from the blocks.

Finishing

To Make a Pillowcase Finish

1. Layer the quilt top right side up on the batting, and place the backing right side down on top of the quilt top. Pin around the edges.

2. Stitch around the edges using a ¼″ seam allowance, leaving a 12″ opening to turn right side out.

3. Turn the quilt right side out and carefully press the edges.

4. Hand stitch the opening closed.

5. Quilt as desired. The original quilt is tied with yarn in the center and along the outside edge of each block.

To Finish the Quilt with Binding

1. Layer the quilt top, batting, and backing.

2. Baste using your preferred method.

3. Quilt as desired.

4. Bind the quilt using your preferred method.

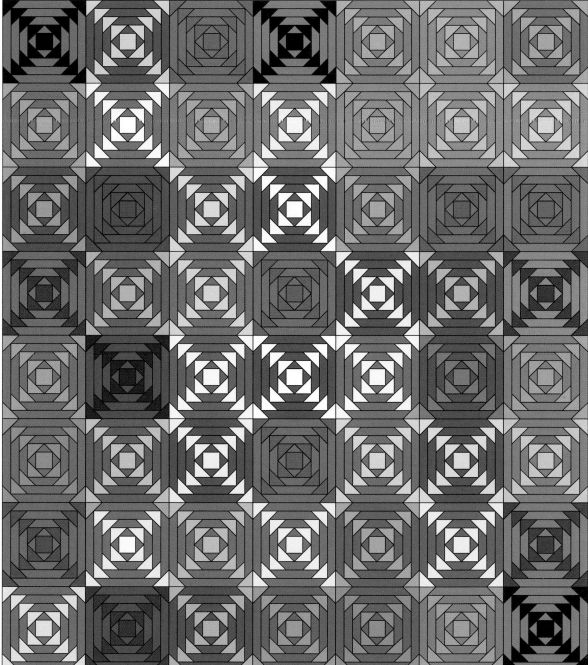

Quilt assembly

Pineapple Log Cabin
Smaller Version

Make 14 blocks to create a runner that is 20½″ × 70½″.

Materials

Dark fabric: 2¼ yards (or 8 fat quarters) for block background

Bright fabric: Approximately 1¼ yards of scraps for center and arrows

Dark fabric: ⅜ yard to make ¼″ finished double-fold binding

Backing: 28″ × 78″

Batting: 28″ × 78″

Cutting

Dark fabric

For each block:

- Cut 1 strip 2¼″ × width of fabric; subcut 2 squares 2¼″ × 2¼″ and cut each square in half diagonally once (B); from the remaining strip cut 4 rectangles 1½″ × 8½″ (F).

- Cut 2 strips 1½″ × width of fabric; subcut 4 rectangles 1½″ × 6½″ (E) and 4 rectangles 1½″ × 4½″ (D).

Bright fabric

For each block:

- Cut 1 strip 2⅞″ × width of fabric; subcut 8 squares 2⅞″ × 2⅞″ and cut each square in half diagonally once (C), and cut 1 square 2½″ × 2½″ (A).

Binding

- Cut 6 strips 1⅝″ × width of fabric.

Refer to Construction (page 42) to make the quilt.

Lone Star

FINISHED QUILT: 75½″ × 75½″
FINISHED STAR: 36½″ × 36½″

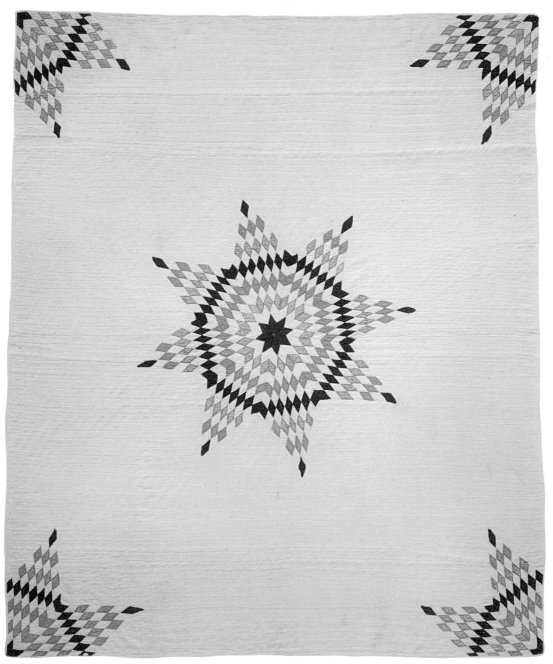

Made from cottons by an unknown maker; Maine; c. 1890

Modern Roots—Today's Quilts from Yesterday's Inspiration

The star is a familiar motif in American patchwork quilting and with good reason—it's been around a long time. Some of the earliest American pieced quilts include stars. Eight-pointed LeMoyne Stars as well as stars with triangles pieced to the edges of squares are commonly seen in the early patchwork designs. Large, central stars made of smaller pieced diamonds appear a bit later, in the second quarter of the nineteenth century, with designs known as Lone Star or Star of Bethlehem.

This Lone Star quilt came from Blueberry Hill Antiques in Rangeley, Maine, and was purchased in August 1994. It was made around 1890 and was one of the first quilts acquired by the Volckening Collection. The quilt is an unusual example of a Lone Star. Typically the star is set with either one or two tips pointing upward. This star is slightly skewed. Often the central star will occupy most of the quilt, but this star is smaller, allowing much more white space.

The quilt is predominantly red, white, and green, with some cheddar orange. Each of the 8 points in the central star and in the corners has 35 diamond-shaped pieces, for a total of more than 560 pieces

in the quilt. It is a lacy, open design with rows of white diamonds alternating with the rows of colored diamonds.

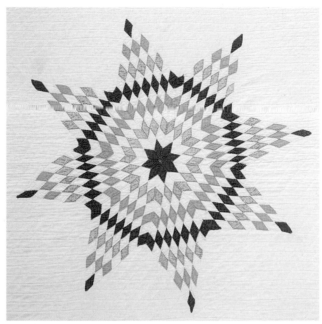

Construction Notes

The original quilt is rectangular (67″ × 84″) and the stars and corner diamonds were appliquéd. If you wish to reproduce the original, piece the background to whatever size you want and appliqué the star and corners as desired. The pattern that follows is for a square quilt with an appliquéd center star and pieced corner diamonds.

Star quilts were not always easy to put together. Many examples of the Lone Star design were never finished due to a common technical problem. When joining the star points at the center, the center point often became tentlike with distortion from the many bias-cut seams. Bulky seams were also a problem. Today's rotary cutters and rulers allow for precise cutting, making construction much easier. For this quilt, pressing seams open helps alleviate bulky seams.

This Lone Star is hand quilted with a basic Hanging Diamonds design, approximately 6 stitches per inch with about an inch between rows, for around 33,000 quilting stitches. Hanging Diamonds is a basic, utilitarian quilting design with rows of parallel lines intersecting at a 45° angle. If this quilt were made with today's fabrics, the white space would allow many creative possibilities. Low-volume fabrics could add interest and texture. Free-motion swirls, curves, and feathers could add richness to the background, and geometric designs could elegantly define those areas.

Materials

Yardage requirements are based on 40″-wide fabric.

Fabric A: ½ yard for Diamond A

Fabric B: 6⅜ yards for background, borders, and Diamond B

Fabric B or alternative: ½ yard to make ¼″ finished double-fold binding

Fabric C: ⅜ yard for Diamond C

Fabric D: ⅜ yard for Diamond D

Backing: 83″ × 83″

Batting: 83″ × 83″

Cutting

Fabric A: Cut 9 strips 1½″ × width of fabric.

Fabric B:

• Cut 24 strips 1½″ × width of fabric.

• From remaining yardage, cut 1 strip 7½″ × length of fabric; subcut 3 strips 7½″ × 55½″.

• From remaining length of fabric, cut 4 right triangles 31″ × 61½″ and 1 strip 7½″ × 55½″ as shown.

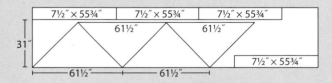

Fabric C: Cut 8 strips 1½″ × width of fabric.

Fabric D: Cut 8 strips 1½″ × width of fabric.

Binding: Cut 9 strips 1⅝″ × width of fabric

Construction

Large Diamond Assembly

Sew all seams with a ¼″ seam allowance unless otherwise noted.

1. Arrange the strips into groups as shown:

	Group 1	Group 2	Group 3	Group 4	Group 5	Group 6	Group 7
Row 7	A	B	C	B	D	B	A
Row 6	B	A	B	C	B	D	B
Row 5	D	B	A	B	C	B	D
Row 4	B	D	B	A	B	C	B
Row 3	C	B	D	B	A	B	C
Row 2	B	C	B	D	B	A	B
Row 1	A	B	C	B	D	B	A

2. Beginning with Group 1, place an A strip (row 1) right side up. Then place a B strip (row 2) above it and 1″ to the right of the A strip.

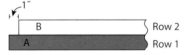

3. Continue to place each successive strip 1″ to the right of the strip beneath it.

4. Sew the strips together, pressing the seams open.

5. Repeat Steps 2–4 to sew the 7 groups.

6. Starting with Group 1, place a ruler along the left edge of the group, aligning the 45° line with a seam, and trim away the stair-stepped edge.

7. Cut 16 strips 1½″ wide, keeping ruler at 45°.

8. Repeat Steps 6 and 7 for remaining sets.

9. Arrange a strip from each group into a diamond as shown.

10. Sew the strips together and press the seams open.

11. Repeat Steps 9 and 10 to make 16 large diamonds. Set aside 8 for corners.

Large Star and Corner Assembly

1. Stitch 2 diamonds together as shown, carefully matching each small diamond seam. Press the seam open.

2. Repeat Step 1 to make 4 pairs.

3. Stitch 2 pairs together, carefully matching each small diamond seam. Press the seam open.

4. Repeat Step 3 to make 2 half-stars.

5. Stitch 2 half-stars together, carefully matching each small diamond seam. Press the seam open.

6. Stay stitch the edge by stitching a scant ¼″ all around raw edge of star.

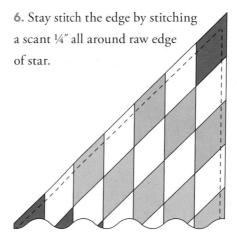

Border Assembly

1. Fold the corner of a 7½″ × 55¾″ border strip along the 45° diagonal and crease.

2. Measure ¼″ above the crease and mark a line.

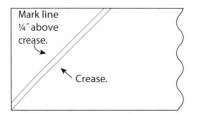

Mark line ¼″ above crease.

Crease.

3. Place a diamond at the end of the border, right sides together, with raw edge of diamond along the marked line. Stitch the diamond to the border and check that the angle is 45° and the outer edges are even before trimming off the triangle at the end of the border.

4. Repeat Steps 1–3 for other end of border, noting reversed orientation of diamond.

5. Repeat Steps 1–4 to make 4 identical borders.

Quilt Assembly

1. Fold a background triangle in half along the long edge and finger-press a crease at the center point.

2. Fold a border strip in half and finger-press a crease at the center point along the shorter inner edge.

3. With right sides together, match the center marks and the ends of a triangle to a border piece, and pin.

4. Sew the border piece to the background triangle. Press the seams toward background.

5. Repeat Steps 1–4 to make 4 background/border triangles.

6. Place 2 background/border triangles right sides together, matching the corner diamond seams, and center point. Pin.

7. Sew the pieces together and press the seam open.

8. Repeat Steps 6 and 7 to make the second large background/border triangle.

9. Place the 2 triangles together, matching the diamond seams at both ends, and pin. Sew the pieces together to make a square. Press the seam open.

10. Center the star on the background as desired, or place so that 4 points match the 4 seams, and pin.

11. Turn under edge of star at staystitching line and appliqué with your favorite method.

Finishing

1. Layer the quilt top, batting, and backing.

2. Baste using your preferred method.

3. Quilt as desired.

4. Bind the quilt using your preferred method.

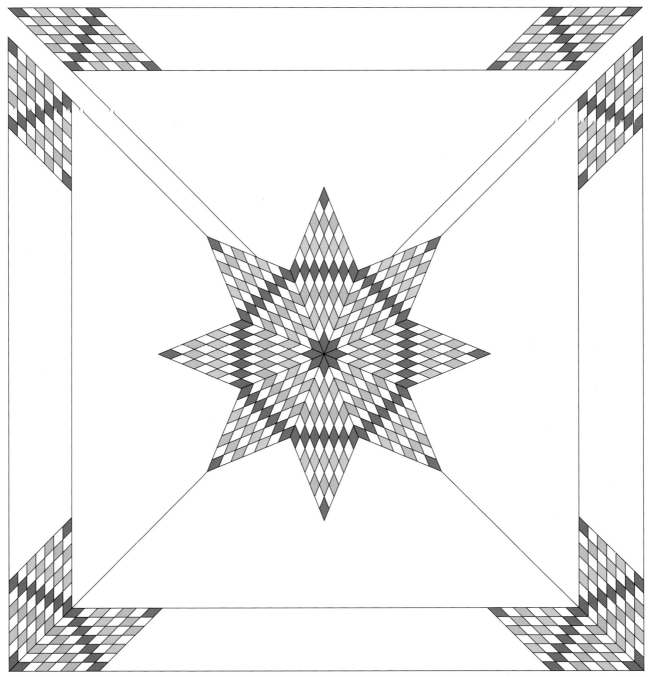

Quilt assembly

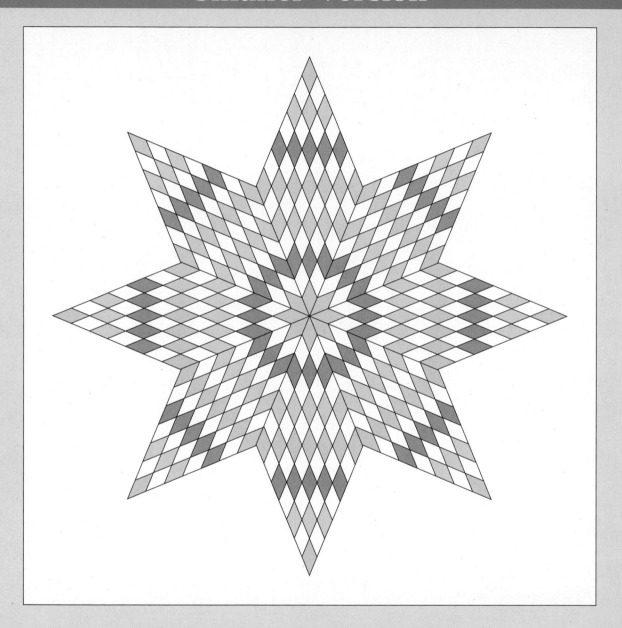

Omit the corner diamonds to create a smaller version that is 40″ × 40″.

Materials

Fabric A: ¼ yard for Diamond A

Fabric B: 1¾ yards for background, borders, and Diamond B

Fabric B or alternate: ⅜ yard to make ¼″ finished double-fold binding

Fabric C: ¼ yard for Diamond C

Fabric D: ¼ yard for Diamond D

Backing: 48″ × 48″

Batting: 48″ × 48″

Cutting

Fabric A: Cut 9 strips 1½″ × 20″.

Fabric B: Cut 1 square 40″ × 40″ and 24 strips 1½″ × 20″.

Fabric C: Cut 8 strips 1½″ × 20″.

Fabric D: Cut 8 strips 1½″ × 20″.

Binding: Cut 5 strips 1⅝″ × width of fabric.

Refer to Construction (page 50) to make the quilt. Cut only 8 pieced strips to make 8 large diamonds for the star.

Log Cabin Boxes

FINISHED QUILT: 51¾" × 51¾"

FINISHED BLOCK: 5¼" × 5¼" (81 blocks, 9 × 9 setting)

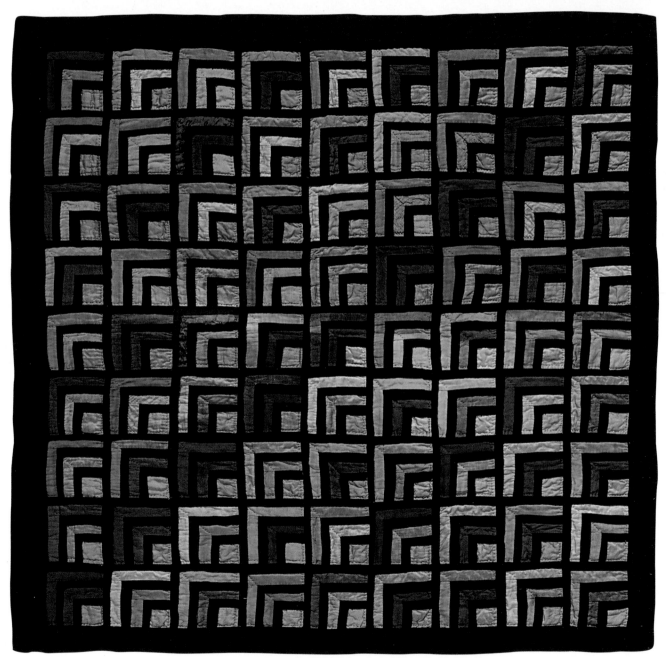

Made from silks and satins by an unknown maker; eastern United States; c. 1900

Modern Roots—Today's Quilts from Yesterday's Inspiration

Until recently, modern quilters rarely included a lot of black in their quilts, but black is one of the unifying elements in this modern-looking Log Cabin quilt made more than 100 years ago. A dazzling variety of colorful silk and satin fabrics shimmer against the black, along with some navy blue. The effect is a contemporary-looking stained-glass window made of cloth—a design so fresh, it is ready for the twenty-first century.

This gem of a quilt is really a diamond in the rough—a rescue quilt. It has condition issues, such as bleeding, fading, and some fabric deterioration. The bleeding is most significant, with dye from the black and navy blue fabrics bleeding onto several of the lighter-colored pieces. It was never meant to get wet, but exposure to moisture likely caused the bleeding.

Quilts in poor condition are sometimes sold as "cutter" quilts. The term *cutter* suggests that quilts in poor condition could be cut into pieces, and the usable bits incorporated into crafting projects—not the best idea when there is something about the quilt worth preserving. This Log Cabin quilt was sold as a cutter, but it was clearly worth rescuing for its unusual design and wonderful use of color.

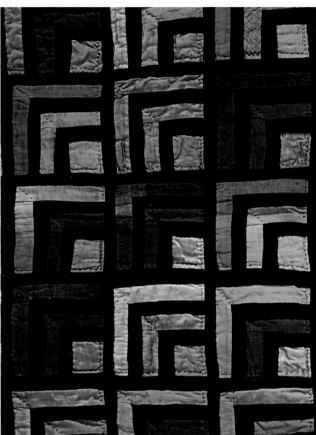

The design includes L-shaped bands of color alternating with black, nested with a small, light blue chimney square in one corner. Colors include blue, brown, gold, green, pink, red, and violet. At first, the L-shaped pieces appear to have mitered seams in the corners, but closer examination shows that the lines through the corners are from the quilting rather than seams, a clever use of hand quilting. The basic quilting, done with four stitches per inch, complements the modern, geometric design.

Construction Notes

There are about a dozen colors in the original version of this quilt. The jewel tones are both warm and cool. To help keep the variety, we suggest starting with ten colors and cutting a few extra strips, so you can vary each block. The original quilt was bound with ribbon sewn to the quilt top, then folded to the back, mitering the corners.

Materials

Yardage requirements are based on 40"-wide fabric.

Fabric 1: ⅜ yard for block chimney squares

Fabric 2: 2½ yards for background logs and borders

Jewel-tone fabrics: ¼ yard each of 10 colors for logs

Fabric 2 or alternative: ⅝ yard to make ½" finished double-fold binding **or** 6 yards ½"-wide ribbon to finish like the original

Backing: 60" × 60"

Batting: 60" × 60"

Cutting

Fabric 1

- Cut 5 strips 2" × width of fabric; subcut 81 chimney squares 2" × 2" (square 1).

Fabric 2

Note: *Border strips can be cut lengthwise or pieced from crosswise strips.*

LENGTHWISE BORDERS:

- Cut 2 strips 2½" × 51¾" lengthwise for side borders.

- Cut 2 strips 2½" × 47¾" lengthwise for top/bottom borders.

- From remaining width of fabric, subcut 38 strips 1¼" × about 30", 3 strips 1¼" × about 35", and 18 strips 1¼" × width of fabric.

or

CROSSWISE BORDERS:

- Cut 6 strips 2½" × width of fabric. Stitch together end to end and subcut borders as noted above for lengthwise borders.

- Cut 49 strips 1¼" × width of fabric:

LOGS:

From 1¼" strips, subcut:

81 rectangles 1¼" × 5¾" (log 11)

81 rectangles 1¼" × 5" (log 10)

81 rectangles 1¼" × 4¼" (log 7)

81 rectangles 1¼" × 3½" (log 6)

81 rectangles 1¼" × 2¾" (log 3)

81 rectangles 1¼" × 2" (log 2)

Jewel-tone fabrics

- From each fabric, cut 4 strips 1¼" × width of fabric; subcut:

9 rectangles 1¼" × 5" (log 9)

9 rectangles 1¼" × 4¼" (log 8)

9 rectangles 1¼" × 3½" (log 5)

9 rectangles 1¼" × 2¾" (log 4)

Binding

- Cut 6 strips 3⅛" × width of fabric.

Construction

Sew all seams with a ¼" seam allowance unless otherwise noted.

Block Assembly

Press the seams away from the square.

1. Sew a strip 2 to the left side of a square 1.

2. Sew a strip 3 to the top of the unit from Step 1.

3. Continue to add strips in numerical order.

4. Repeat Steps 1–3 to make 81 blocks.

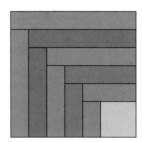

Quilt Assembly

1. Arrange the blocks in a 9 × 9 grid.

2. Sew 9 blocks together to complete each row.

3. Sew the 9 rows together.

4. Sew the 47¾″-long borders to top and bottom. Press the seams toward the borders.

5. Sew the 51¾″-long borders to sides. Press the seams toward the borders.

Finishing

1. Layer the quilt top, batting, and backing.

2. Baste using your preferred method.

3. Quilt as desired. The original quilt was hand quilted ¼″ inside the block, and then diagonally from the inner point of the chimney square (1) to the upper left corner of the block.

4. Bind the quilt using your preferred method and a ½″ seam allowance.

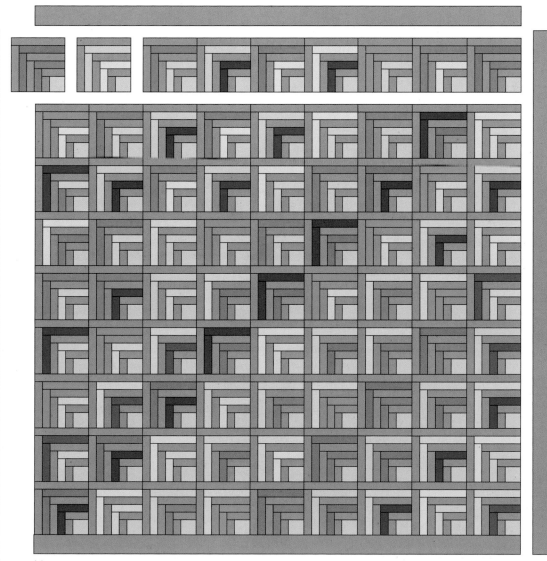

Quilt assembly

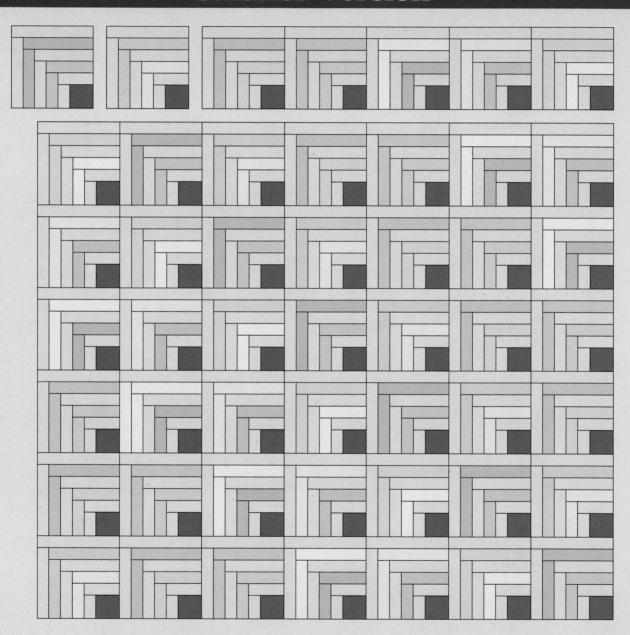

Make 49 blocks to create a smaller version without borders that measures 37¼″ × 37¼″.

Materials

Fabric 1: ¼ yard for block chimney squares

Fabric 2: 1¼ yards for background logs

Shades of one color: ¼ yard each of 7 colors for logs

Fabric 2 or alternative: ⅜ yard to make ¼″ finished double-fold binding

Backing: 45″ × 45″

Batting: 45″ × 45″

Cutting

Fabric 1

• Cut 3 strips 2″ × width of fabric; subcut 49 chimney squares 2″ × 2″ (square 1).

Fabric 2

• Cut 32 strips 1¼″ × width of fabric; subcut:

49 rectangles 1¼″ × 5¾″ (log 11)

49 rectangles 1¼″ × 5″ (log 10)

49 rectangles 1¼″ × 4¼″ (log 7)

49 rectangles 1¼″ × 3½″ (log 6)

49 rectangles 1¼″ × 2¾″ (log 3)

49 rectangles 1¼″ × 2″ (log 2)

Jewel-tone fabrics

• From each fabric, cut 3 strips 1¼″ × width of fabric; subcut:

7 rectangles 1¼″ × 5″ (log 9)

7 rectangles 1¼″ × 4¼″ (log 8)

7 rectangles 1¼″ × 3½″ (log 5)

7 rectangles 1¼″ × 2¾″ (log 4)

Binding

• Cut 5 strips 1⅝″ × width of fabric.

Refer to Construction (page 58) to make the quilt.

Radiating Fans

FINISHED QUILT: 70½" × 80½"

FINISHED BLOCK: 10" × 10" (56 blocks, 7 × 8 setting)

Made from wools and silks by an unknown maker; Texas; c. 1920

Modern Roots—Today's Quilts from Yesterday's Inspiration

The fascination with Asian culture popularized the use of fans as ladies' accessories in the Victorian period, and fans appeared in quilts around the same time. They were prevalent in Victorian crazy quilts, highly embellished with embroidery, and made of fancy materials such as silk, satin, and velvet. Fans were also popular in the twentieth century, when a variety of materials and block designs gave new life to the motif.

After the Victorian period, the fan was typically seen in quilts as a repeat block design. Fan blocks appeared in rows, usually facing one direction; but sometimes blocks were rotated and configured to create secondary designs such as curvy snake trails and circular sunbursts. The earliest fan block designs were published around the turn of the century and given names such as Sunshine, the block created by Clara Stone in 1906.

This Radiating Fans quilt came from an eBay seller in Texas. It has 56 blocks, each with 8 pieces.

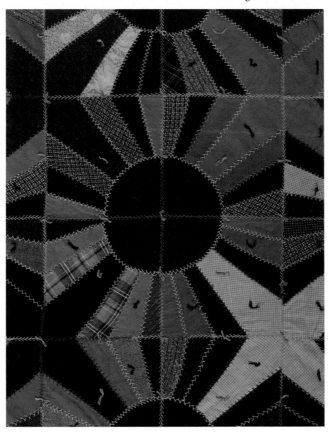

The fans were made with rich, earthy colors such as blue, brown, green, and burnt orange. The fabrics look like remnants from garment making, new when the quilt was made.

Each fan has a pie-shaped, quarter-circle wedge at the base, in jewel-tone red. When four blocks are grouped with the red wedges turned toward each other, the blocks create a multicolor, radiating sunburst design with a red circle in the center. Nine complete circles are formed by the four-block sets, and partial circles line three edges.

Another secondary design, an X shape, is formed at the intersecting points of four blocks with the same or close to the same color in the large, corner rays.

The most prominent X is off-white, toward the lower right. Having multiple secondary designs offers a wide variety of creative possibilities. The focus could be the circles, the X's, or both; it could be a scrappy quilt as easily as it could be a two-color quilt.

Construction Notes

Most of the blocks in the original quilt have the fans mirrored on either side of the corner fan piece. The yardage calculations are for this arrangement, but feel free to make your quilt scrappy. The original also did not have an additional binding, but rather the backing was folded around to the front and stitched down. Instructions that follow include both methods.

Materials

Yardage requirements are based on 40"-wide fabric.

Fan fabrics: ¾ yard each of 14 fabrics **or** about 10½ yards of a variety of scraps for fans

Quarter-circle fabric: 1⅜ yards **or** enough scraps, each at least 5½" × 5½"

Binding: 1 yard to make ½" finished double-fold binding

Backing: 78" × 88"

Batting: 78" × 88"

Cutting

Make templates A, B, C, D, and E using Radiating Fans patterns (pullout page P1). All patterns include a ¼" seam allowance.

Fan fabrics

• Cut 56 pairs of A and A-reversed, B and B-reversed, C and C-reversed blades.

• Cut 56 D blades.

Quarter-circle fabric(s)

• Cut 56 E quarter-circles.

Binding

• Cut 9 strips 3⅛" × width of fabric.

Construction

Sew all seams with a ¼" seam allowance unless otherwise noted.

Block Assembly

1. Arrange blade pieces A, B, C, D, C-r, B-r, and A-r for each block.

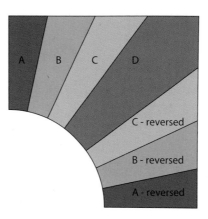

2. Sew the blades together in order, right sides together, matching each end at the ¼" seam intersection. Press the seams open.

3. Repeat Steps 1 and 2 to make 56 fans.

4. Fold a quarter-circle E piece in half wrong sides together along the curve and finger-press a crease at the edge.

Fold.

5. Fold a fan unit in half diagonally right sides together, and finger-press a crease at the midway point on the edge of D.

6. Place the quarter-circle E and the fan unit right sides together, matching the center creases and ends. Pin the pieces together.

7. Sew the fan unit to E with the E piece on the bottom and the fan unit on the top. Press the seam toward the E piece.

8. Repeat Steps 4–7 to make 56 blocks.

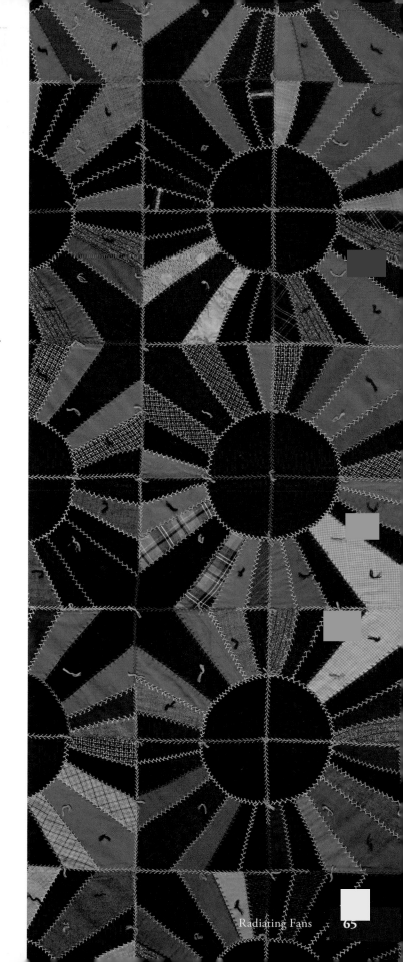

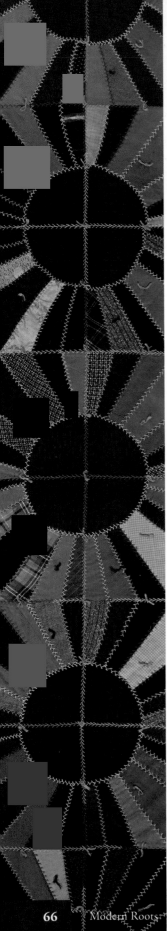

Quilt Assembly

1. Arrange the blocks in a 7 × 8 grid.

2. Sew the blocks together into rows.

3. Sew the rows together.

Finishing

To Finish Like the Original Quilt

1. Layer the quilt top, batting, and backing.

2. Baste using your preferred method.

3. Tie the quilt together at the points illustrated, using embroidery floss.

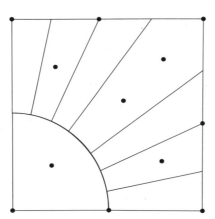

4. Embroider along each seam with a feather stitch or your favorite embroidery stitch.

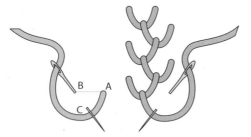

5. Trim the backing to 1½″ larger than quilt top.

6. Trim the batting even with quilt top.

7. Along a side of the quilt, fold the backing to meet the quilt top edge, then fold again to cover the edge. Hand stitch in place, then repeat for the other side.

8. Fold the top and bottom edges in the same manner and hand stitch in place to finish the quilt.

To Finish the Quilt with Binding

1. Layer the quilt top, batting, and backing.

2. Baste using your preferred method.

3. Quilt as desired.

4. Bind the quilt using your preferred method and a ½″ seam allowance.

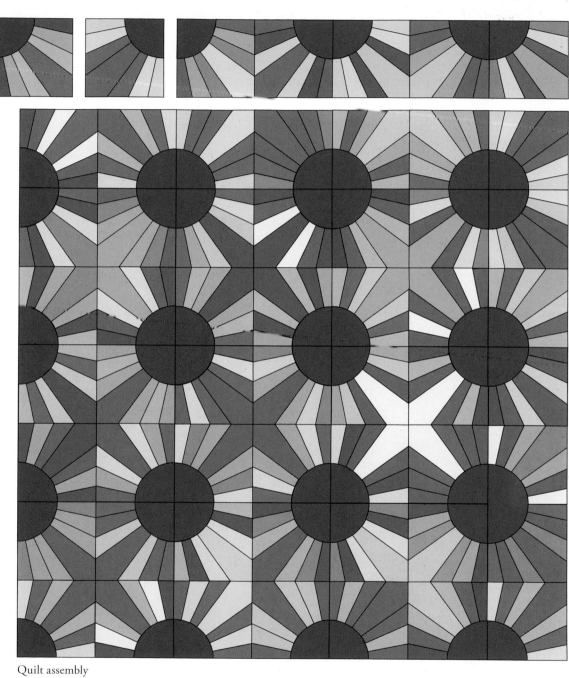

Quilt assembly

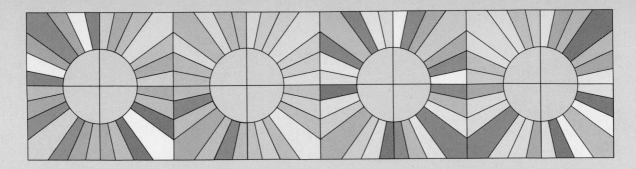

Make 16 blocks to create a runner that is 20½ × 80½".

Materials

Fan fabrics: ¼ yard each of 16 fabrics **or** 4 yards of scraps (minimum 9″ × 25″ for 1 block set)

Quarter-circle fabric: ½ yard

Binding: ⅝ yard to make ½″ finished double-fold binding

Backing: 28″ × 88″

Batting: 28″ × 88″

Cutting

Make templates A, B, C, D, and E using Radiating Fans patterns (pullout page P1). All patterns include a ¼″ seam allowance.

Fan fabrics

From each fan fabric:

• Cut 1 pair of A and A-reversed, B and B-reversed, C and C-reversed blades, and 1 D blade, for a total of 16 sets.

Quarter-circle fabric

• Cut 16 E quarter-circles.

Binding

• Cut 6 strips 3⅛″ × width of fabric.

Shuffle the pairs of blades to get a variety for each block. Refer to Construction (page 64) to make the quilt.

Barn Raising Log Cabin

FINISHED QUILT: 88½″ × 88½″

FINISHED BLOCK: 12½″ × 12½″ (36 blocks, 6 × 6 setting)

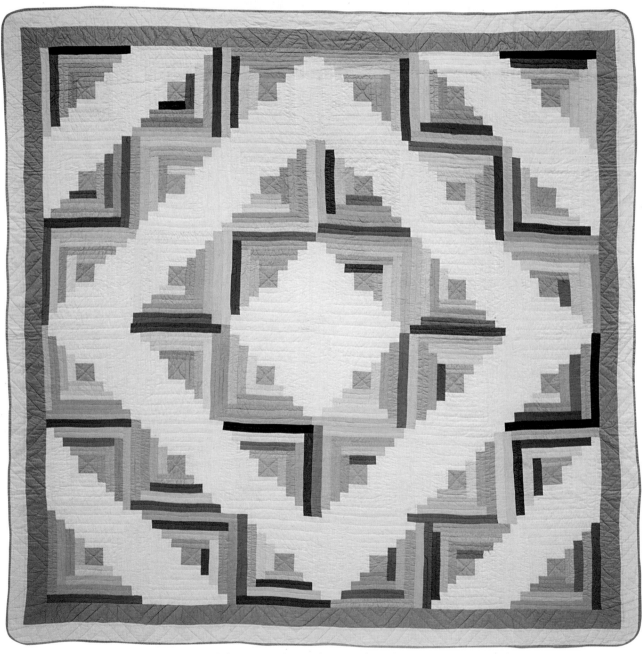

Made from cottons by an unknown maker; Ohio; c. 1930

Modern Roots—Today's Quilts from Yesterday's Inspiration

og Cabin quilts were first made in the third quarter of the nineteenth century, after the Civil War and beyond. They were among the only foundation-pieced quilts, along with crazy quilts, English paper-pieced hexagon quilts, and later string quilts. Folklore might suggest a connection between Abraham Lincoln, who was born in a log cabin, and the popularity of the Log Cabin quilt pattern. However, there is a lack of documentation to support that idea.

Barn Raising Log Cabin is a traditional quilt setting made of blocks constructed with strips forming two interlocking triangles, one light and the other dark. These blocks often have red squares in the centers and include a wide selection of dark print fabrics and light neutral prints. The blocks are the building blocks for a larger, concentric diamond-in-square composition.

It is uncommon to see an antique or vintage Barn Raising Log Cabin quilt made with all solid fabrics, and especially rare to see one made predominantly with white and rainbow pastel solids. This 1930s Barn Raising Log Cabin quilt from Ohio is so

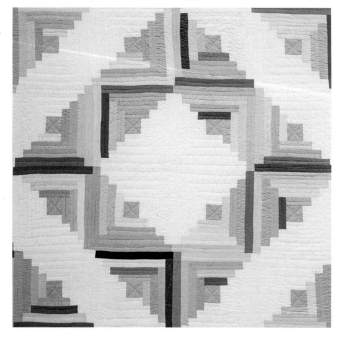

Construction Notes

There are more than 20 colors in the original version of this quilt. To help keep the variety, we suggest using 18 to 36 colors, so you can get a good variety in each block.

modern looking, it seems like the maker could have shopped for fabrics in 2015. The use of lavender, a popular color in the Depression era, is a clue to the quilt's age, and there is a very light patina from handling, seen in the white. Otherwise, it could have been made yesterday.

There are 36 blocks, each with half white and half multicolor strips, and a lavender center square. It does not appear to be foundation pieced, as other Log Cabins often are; and the strips with stronger, darker colors accentuate the directional lines in the quilt. The white piecework creates negative space, with the seams and quilting adding a hint of understated, linear texture.

When people see this quilt for the first time, they are often surprised to hear it is more than 80 years old. The quilt has never been washed and the fabrics are crisp, as if they came from the mill just yesterday. As an inspiration piece, it would be a great way to use scraps. Low-volume neutrals in the background paired with bright and light colors would be a simple way to update the design, but it could also work well without much change.

Materials

Yardage requirements are based on 40"-wide fabric.

Fabric 1: 4 yards for solid half of blocks and outer border

Fabric 2: 1½ yards for chimney square and inner border

Variety of fabrics: ⅛ yard of 36 different fabrics **or** 18 (or more!) fat quarters for total of 4½ yards for log strips

Binding: 1 yard to make ½" finished double-fold binding

Backing: 96" × 96"

Batting: 96" × 96"

Cutting

Fabric 1

• Cut 9 strips 3¾" × width of fabric; stitch the strips together end to end and subcut 2 strips 3¾" × 88½" and 2 strips 3¾" × 82" for the outer border.

> **TIP**
>
> Cut 10 strips at a time and then do the subcutting so as not to end up with a tangle of 55 strips and risk having their edges ravel.

• Cut 55 strips 1¾" × width of fabric; subcut:

36 rectangles 1¾" × 11¾" (log 15)

36 rectangles 1¾" × 10½" (log 14)

36 rectangles 1¾" × 9¼" (log 11)

36 rectangles 1¾" × 8" (log 10)

36 rectangles 1¾" × 6¾" (log 7)

36 rectangles 1¾" × 5½" (log 6)

36 rectangles 1¾" × 4¼" (log 3)

36 rectangles 1¾" × 3" (log 2)

Fabric 2

• Cut 8 strips 3¾" × width of fabric; stitch the strips together end to end and subcut 2 strips 3¾" × 82" and 2 strips 3¾" × 75½" for the inner borders.

• Cut 3 strips 3" × width of fabric; subcut 36 squares 3" × 3" for chimney blocks (square 1).

Multicolor logs

• From each fabric, depending on how many fabrics you are using, cut 1 or 2 rectangles of each size below, for a total of:

36 rectangles 1¾" × 13" (log 17)

36 rectangles 1¾" × 11¾" (log 16)

36 rectangles 1¾" × 10½" (log 13)

36 rectangles 1¾" × 9¼" (log 12)

36 rectangles 1¾" × 8" (log 9)

36 rectangles 1¾" × 6¾" (log 8)

36 rectangles 1¾" × 5½" (log 5)

36 rectangles 1¾" × 4¼" (log 4)

Binding

• Cut 10 strips 3⅛" × width of fabric.

Construction

Sew all seams with a ¼" seam allowance unless otherwise noted.

Block Assembly

Press the seams away from the square.

1. Sew a strip 2 to the top side of a square 1.

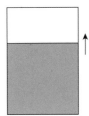

2. Sew a strip 3 to the left side of the unit from Step 1.

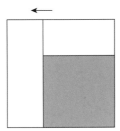

3. Sew a strip to the bottom side of the unit from Step 2.

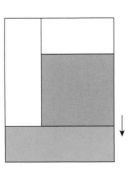

4. Sew a strip 5 to the right-hand side of the unit from Step 3.

5. Continue to add strips in numerical order.

6. Repeat Steps 1–5 to make 36 blocks

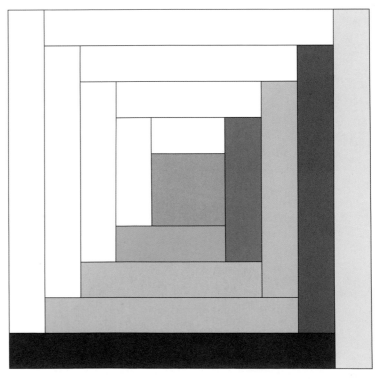

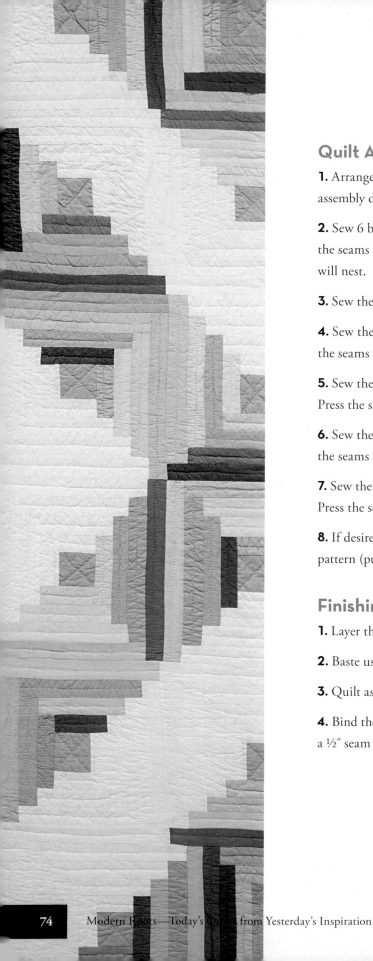

Quilt Assembly

1. Arrange the blocks in a 6 × 6 grid, following the quilt assembly diagram or your own design.

2. Sew 6 blocks together to complete each row, pressing the seams in each row in opposite directions so that they will nest.

3. Sew the 6 rows together, matching the block seams.

4. Sew the 75½″-long Fabric 2 borders to the sides. Press the seams toward the borders.

5. Sew the 82″-long Fabric 2 borders to top and bottom. Press the seams toward the borders.

6. Sew the 82″-long Fabric 1 borders to the sides. Press the seams toward the outer borders.

7. Sew the 88½″-long Fabric 1 borders to top and bottom. Press the seams toward the outer borders.

8. If desired, trim the corners using Log Cabin Corner pattern (pullout page P1).

Finishing

1. Layer the quilt top, batting, and backing.

2. Baste using your preferred method.

3. Quilt as desired.

4. Bind the quilt using your preferred method and a ½″ seam allowance.

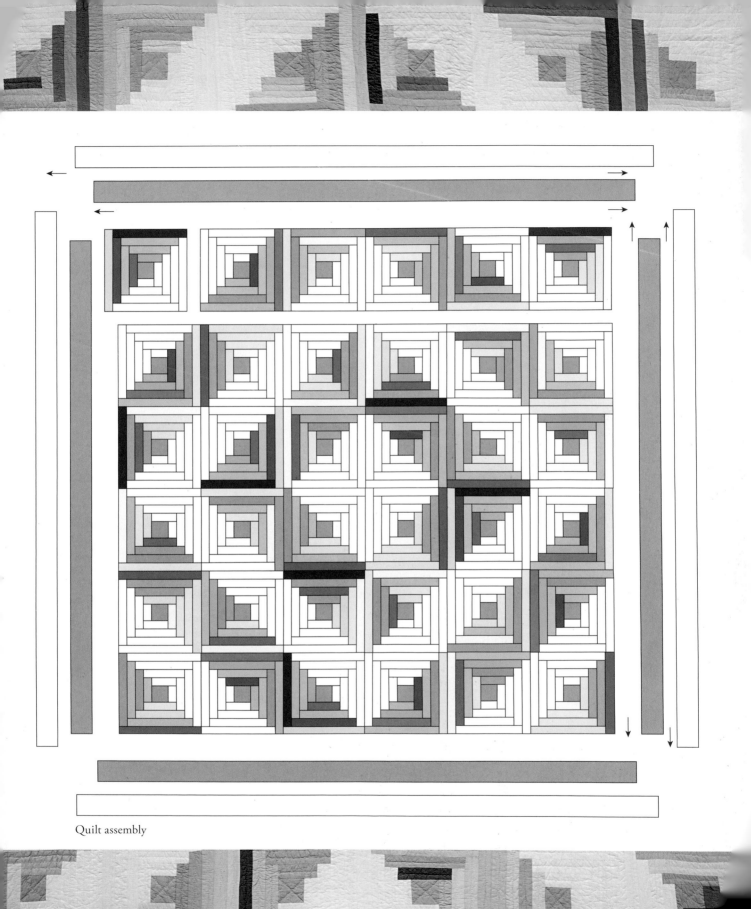

Quilt assembly

Make 9 blocks to create a smaller version that is 51″ × 51″.

Materials

Fabric 1: 1½ yards for solid half of blocks and outer border

Fabric 2: ¾ yard for chimney square and inner border

Variety of fabrics: ⅛ yard each of 9 different fabrics for log strips

Binding: ⅝ yard to make ½" finished double-fold binding

Backing: 59" × 59"

Batting: 59" × 59"

Cutting

Fabric 1

- Cut 5 strips 3¾" × width of fabric; stitch the strips together end to end and subcut 2 strips 3¾" × 51" and 2 strips 3¾" × 44½" for the outer border.

- Cut 14 strips 1¾" × width of fabric; subcut:

 9 rectangles 1¾" × 11¾" (strip 15)

 9 rectangles 1¾" × 10½" (strip 14)

 9 rectangles 1¾" × 9¼" (strip 11)

 9 rectangles 1¾" × 8" (strip 10)

 9 rectangles 1¾" × 6¾" (strip 7)

 9 rectangles 1¾" × 5½" (strip 6)

 9 rectangles 1¾" × 4¼" (strip 3)

 9 rectangles 1¾" × 3" (strip 2)

Fabric 2

- Cut 5 strips 3¾" × width of fabric; stitch together end to end and subcut 2 strips 3¾" × 44½" and 2 strips 3¾" × 38" for the inner borders.

- Cut 1 strip 3" × width of fabric; subcut 9 squares 3" × 3" for the chimney blocks (square 1).

Multicolor logs

- From each of 9 fabrics, cut:

 1 rectangle 1¾" × 13" (strip 17)

 1 rectangle 1¾" × 11¾" (strip 16)

 1 rectangle 1¾" × 10½" (strip 13)

 1 rectangle 1¾" × 9¼" (strip 12)

 1 rectangle 1¾" × 8" (strip 9)

 1 rectangle 1¾" × 6¾" (strip 8)

 1 rectangle 1¾" × 5½" (strip 5)

 1 rectangle 1¾" × 4¼" (strip 4)

Binding

- Cut 6 strips 3⅛" × width of fabric.

Refer to Construction (page 73) to make the quilt.

Indiana Puzzle

FINISHED QUILT: 60" × 77"

FINISHED BLOCK: 8½" × 8½" (63 blocks, 31 pieced and 32 solid, 7 × 9 setting)

Made from cottons by Sarah Nixon; Verona, New Jersey; c. 1935

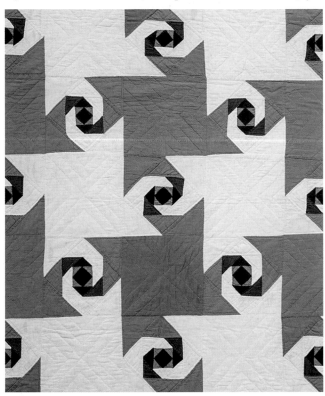

Negative space is a key component in works of modern art, especially those with elements of graphic design. This Indiana Puzzle quilt cleverly makes use of negative space with the inclusion of solid blocks alternating with the pieced blocks. Indiana Puzzle, also called Monkey Wrench, Snail's Trail, and many other names, is a design first seen in the late nineteenth and early twentieth centuries. Ladies Art Company of St. Louis, Missouri, published a basic version called Snail's Trail in 1928, and many similar designs from other publishers soon followed.

Each pieced block has 21 patches: 8 white, 8 periwinkle blue, 3 dark blue, and 2 royal blue. The pieced blocks alternate with solid blocks in blue and white, which blend in with the edge colors in the pieced blocks, creating the illusion of larger, more complex shapes. The hand quilting was done at 6–8 stitches per inch with roughly an inch separating the rows in most places—well over 30,000 quilting stitches.

The Ladies Art Company Snail's Trail design from 1928 has 16 patches and suggests using solid blocks, light and dark, alternating with the pieced blocks. *Kansas City Star*'s 1935 pattern has 24 patches and was published as an "allover" design of pieced blocks with no solid blocks. This blue and white quilt is somewhere in between. Its pieced block is more closely related to the *Kansas City Star* pattern, but the method of setting the pieced the blocks alternating with solid blocks is more akin to the earlier published design from Ladies Art Company.

Sarah Nixon made this pretty little blue and white quilt for Elizabeth Draycott Ost, my mother, in Verona, New Jersey, around 1935. Sarah was African-American, born around 1902 in North Carolina, and was listed as a member in the Ryan household in the 1940 census. Mom remembers Sarah, an imposing figure but a perfectly lovely woman. Sarah could not read, but thoroughly enjoyed making quilts. She was in her early to middle 30s when she made Mom's quilt, and clearly she had a great sense of color and design.

Construction Notes

The original quilt contains a mix of several shades for the light blue. Some of the blue that is mismatched is a later restoration c. 2000. The pattern is written for a single fabric, but feel free to mix in others as you wish.

Materials

Yardage requirements are based on 40"-wide fabric.

Dark blue: ⅜ yard

Royal blue: ⅜ yard

Periwinkle blue: 2½ yards

White: 3⅛ yards

Dark blue: ⅝ yard to make ⅜" finished double-fold binding

Backing: 68" × 85"

Batting: 68" × 85"

Cutting

Dark blue

• Cut 2 strips 2⅜" × width of fabric; subcut 31 squares 2⅜" × 2⅜"; cut the squares in half once diagonally for D triangles.

• Cut 2 strips 2" × width of fabric; subcut 31 squares 2" × 2" for A squares.

Royal blue

• Cut 3 strips 3" × width of fabric; subcut 31 squares 3" × 3"; cut the squares in half once diagonally for F triangles.

Periwinkle blue

• Cut 3 strips 9" × width of fabric; subcut 12 squares 9" × 9" for alternate blocks.

• Cut 5 strips 5⅛" × width of fabric; subcut 31 squares 5⅛" × 5⅛"; cut the squares in half once diagonally for J triangles.

• Cut 4 strips 3⅞" × width of fabric; subcut 31 squares 3⅞" × 3⅞"; cut the squares in half once diagonally for H triangles.

• Cut 4 strips 2" × width of fabric; subcut 62 squares 2" × 2"; cut the squares in half once diagonally for B triangles.

White

• Cut 5 strips 9" × width of fabric; subcut 20 squares 9" × 9" for alternate blocks.

• Cut 5 strips 5⅛" × width of fabric; subcut 31 squares 5⅛" × 5⅛"; cut the squares in half once diagonally for I triangles.

• Cut 4 strips 3⅞" × width of fabric; subcut 31 squares 3⅞" × 3⅞"; cut the squares in half once diagonally for G triangles.

• Cut 3 strips 3" × width of fabric; subcut 31 squares 3" × 3"; cut the squares in half once diagonally for E triangles.

• Cut 2 strips 2⅜" × width of fabric; subcut 31 squares 2⅜" × 2⅜"; cut the squares in half once diagonally for C triangles.

Binding

• Cut 8 strips 2⅜" × width of fabric.

Construction

Sew all seams with a ¼" seam allowance unless otherwise noted.

Block Assembly

Press the seams away from the square.

1. Sew 2 B triangles to opposite sides of an A square. Press.

2. Repeat Step 1 to sew 2 more B triangles to the remaining sides of the A square.

3. Sew 2 C triangles to opposite sides of the square from Step 2. Press.

4. Sew 2 D triangles to the remaining sides of the square from Step 2. Press.

5. Repeat Steps 3 and 4 to sew sets of E–J triangles to each successive square, noting the position in the illustration.

6. Repeat Steps 1–5 to make 31 blocks.

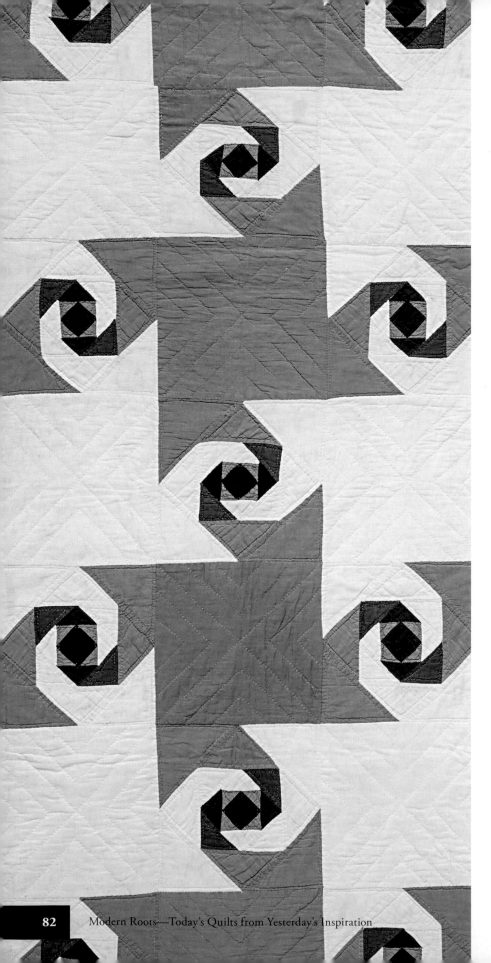

Quilt Assembly

1. Arrange the blocks in a 7 × 9 grid, alternating the pieced blocks with the solid white and periwinkle blue blocks as shown.

2. Sew 7 blocks together to complete each row.

3. Sew the 9 rows together.

Finishing

1. Layer the quilt top, batting, and backing.

2. Baste using your preferred method.

3. Quilt as desired.

4. Bind the quilt using your preferred method and a ⅜″ seam allowance.

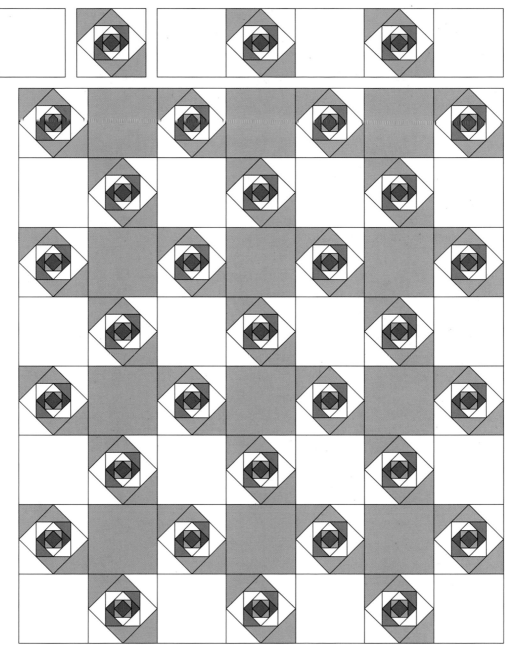

Quilt assembly

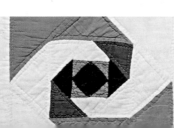

Indiana Puzzle
Smaller Version

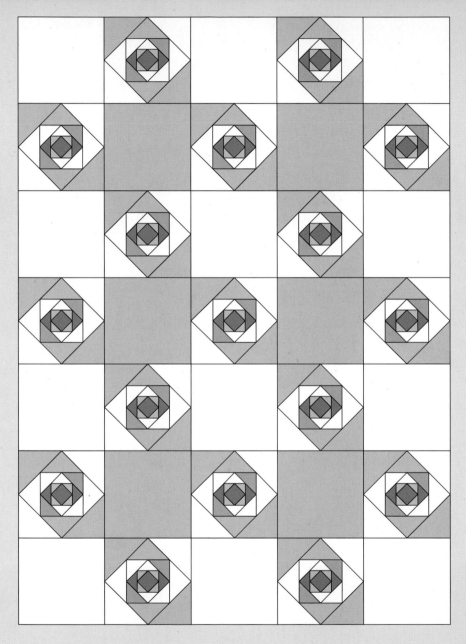

Make 35 blocks (17 pieced and 18 solid, 5 × 7 layout) to create a smaller version that is 43″ × 60″.

Materials

Dark: ¼ yard for A center square and D triangles

Medium: ¼ yard for F triangles

Light: 1½ yards for B, H, and J triangles, and alternate blocks

Neutral: 2 yards for C, E, G, and I triangles, and alternate blocks

Dark: ½ yard to make ⅜″ finished double-fold binding

Backing: 51″ × 68″

Batting: 51″ × 68″

Cutting

Dark

- Cut 2 strips 2⅜″ × width of fabric; subcut 17 squares 2⅜″ × 2⅜″; cut the squares in half once diagonally for D triangles; cut 17 squares 2″ × 2″ for A squares.

Medium

- Cut 2 strips 3″ × width of fabric; subcut 17 squares 3″ × 3″; cut the squares in half once diagonally for F triangles.

Light

- Cut 2 strips 9″ × width of fabric; subcut 6 squares 9″ × 9″ for alternate blocks.

- Cut 3 strips 5⅛″ × width of fabric; subcut 17 squares 5⅛″ × 5⅛″; cut the squares in half once diagonally for J triangles.

- Cut 2 strips 3⅞″ × width of fabric; subcut 17 squares 3⅞″ × 3⅞″; cut the squares in half once diagonally for H triangles.

- Cut 2 strips 2″ × width of fabric; subcut 34 squares 2″ × 2″; cut the squares in half once diagonally for B triangles.

Neutral

- Cut 3 strips 9″ × width of fabric; subcut 12 squares 9″ × 9″ for alternate blocks.

- Cut 3 strips 5⅛″ × width of fabric; subcut 17 squares 5⅛″ × 5⅛″; cut the squares in half once diagonally for I triangles.

- Cut 2 strips 3⅞″ × width of fabric; subcut 17 squares 3⅞″ × 3⅞″; cut the squares in half once diagonally for G triangles.

- Cut 2 strips 3″ × width of fabric; subcut 17 squares 3″ × 3″; cut the squares in half once diagonally for E triangles.

- Cut 2 strips 2⅜″ × width of fabric; subcut 17 squares 2⅜″ × 2⅜″; cut the squares in half once diagonally for C triangles.

Binding

- Cut 6 strips 2⅜″ × width of fabric.

Refer to Construction (page 81) to make the quilt.

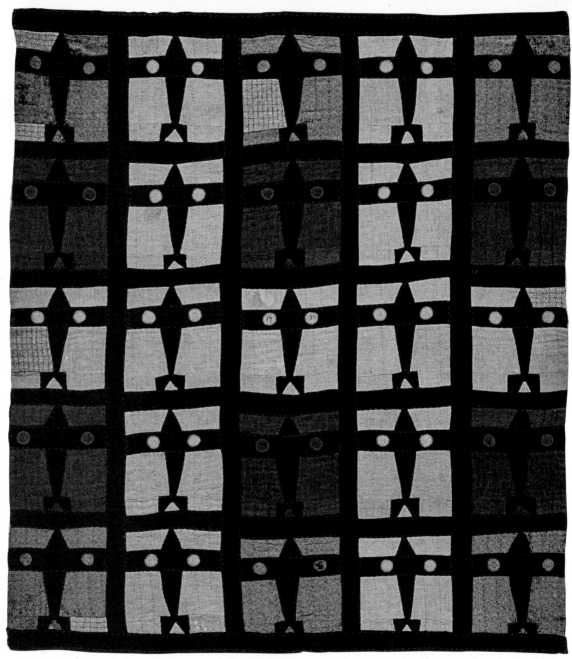

Made from wools by an unknown maker; western Pennsylvania; dated 1937

On May 20, 1927, 25-year-old Charles Lindbergh took off from Roosevelt Field in Garden City, New York, for a 33-hour, 3,600-mile nonstop air flight to Le Bourget Field in Paris. It was the first nonstop transatlantic flight, and Lindbergh was the first person in history to be in New York one day and Paris the next. "Lucky Lindy" was instantly famous, along with his single-seat, single-engine airplane, the *Spirit of St. Louis.*

Shortly after Lindbergh's historic transatlantic flight, several quilt block designs featuring aircraft were published. The *Kansas City Star* published the Aircraft Quilt on June 13, 1929. The *Oklahoma Farmer-Stockman* and *Successful Farming* also published airplane designs in 1929, followed by *Capper's Weekly,* Aunt Martha, Ruby McKim, and Carrie Hall in the 1930s.

Even though many airplane quilt block designs were published, vintage airplane quilts are scarce. This wool Airplanes quilt from western Pennsylvania is a rare example of an uncommon pattern. It does not match any designs found in Barbara Brackman's

Encyclopedia of Pieced Quilt Patterns, a seminal identification book with more than 4,000 patterns.

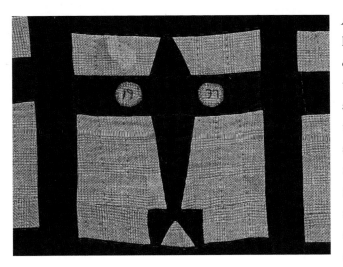

Construction Notes

The original quilt was made of suiting wools and has a definite pattern of background fabric colors paired to airplane colors, which is repeated in the yardage calculations here. The sashing and borders are made from various pieces of navy and black; however, the yardage given is for one color for both. You can certainly mix it up if you wish. The circles on the wings are appliquéd with blanket stitch, and the center airplane has the year, 1937, embroidered in the circles, two digits in each circle. The original quilt was not bound but used a pillowcase finish.

Airplanes shares similarities with published designs depicting the airplane aiming straight up. Some of those patterns include a single propeller at the nose, but this quilt does not have one. Instead, there are circles appliquéd to the wings, one on each side—but what the circles are meant to depict is not clear.

A variety of wool fabrics such as solid navy blue and earthy tweeds were used. These fabrics were not always perfectly matched. There is an element of scrappiness, but the blocks were thoughtfully arranged by the value of the background, creating a larger grid design. All the navy blue pieces were outlined with stitching in heavy red floss. The date, 1937, is embroidered in the wing circles of the center block, using the same red floss.

Almost 80 years after the quilt was made, the subject matter is even more relevant. Lindbergh's flight ushered in the era of modern travel, and today millions of people fly around the world each day. This quilt will be a winner no matter how you make it.

Materials

The materials list includes quantities for 60"-wide wool fabric or 40"-wide cotton fabric, including binding.

60"-WIDE FABRIC:

Background 1 (tan): ⅝ yard for 6 blocks

Background 2 (light gray): 1⅜ yards for 13 blocks

Background 3 (dark gray): ⅝ yard for 6 blocks

Navy (on light gray): ⅝ yard for 13 blocks

Black (on dark gray and tan): ⅝ yard for 12 blocks

Black or navy: 1⅛ yards for sashing and borders

Black or navy: ⅝ yard to make ½" finished double-fold binding

40"-WIDE FABRIC:

Background 1 (tan): ⅞ yard for 6 blocks

Background 2 (light gray): 1⅞ yards for 13 blocks

Background 3 (dark gray): ⅞ yard for 6 blocks

Navy (on light gray): 1 yard for 13 blocks

Black (on dark gray and tan): 1 yard for 12 blocks

Black or navy: 1¾ yards for sashing and borders

Black or navy: ⅞ yard to make ½" finished double-fold binding

60"- OR 40"-WIDE FABRIC:

Perle cotton or embroidery floss (optional, for appliqué and hand quilting)

Backing: 76" × 86"

Batting: 76" × 86"

Cutting

Make templates A, B, D, E, F, and I using Airplane patterns (pullout pages P1 and P2). The original D circle was raw-edge appliquéd. Add your preferred seam allowance to appliqué patterns D and I. All other pattern pieces include a ¼" seam allowance.

Background 1

- Cut 6 each of patterns A, A-reverse, E, E-reverse, and I.
- Cut 12 D circles.
- Cut 12 rectangles 2¾" × 4½" for G.

Background 2

- Cut 13 each of patterns A, A-reverse, E, E-reverse, and I.
- Cut 26 D circles.
- Cut 26 rectangles 2¾" × 4½" for G.

Background 3

- Cut 6 each of patterns A, A-reverse, E, E-reverse, and I.
- Cut 12 D circles.
- Cut 12 rectangles 2¾" × 4½" for G.

Navy

- Cut 13 each of patterns B and F.
- Cut 13 rectangles 3" × 12" for C.
- Cut 13 rectangles 2¾" × 4" for H.

Black

- Cut 12 each of patterns B and F.
- Cut 12 rectangles 3" × 12" for C.
- Cut 12 rectangles 2¾" × 4" for H.

Sashing and borders

60"-WIDE FABRIC:

- Cut 12 strips 3" × width of fabric; subcut 4 strips into 20 sashing rectangles 3" × 12".
- Sew the remaining 8 strips together end to end; subcut into 4 sashing strips 3" × 73" and 2 border strips 3" × 68".

or

40"-WIDE FABRIC:

- Cut 18 strips 3" × width of fabric; subcut 7 strips into 20 sashing rectangles 3" × 12".
- Sew the remaining 11 strips together end to end; subcut into 4 sashing strips 3" × 73" and 2 border strips 3" × 68".

Binding

60"-WIDE FABRIC:

- Cut 6 strips 3⅛" × width of fabric.

or

40"-WIDE FABRIC:

- Cut 9 strips 3⅛" × width of fabric.

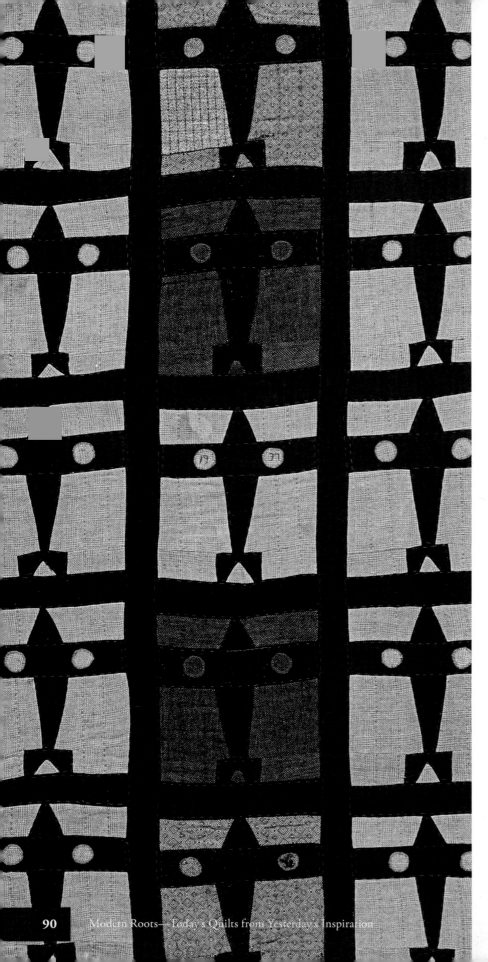

Construction

Sew all seams with a ¼" seam allowance unless otherwise noted.

Block Assembly

Press the seams to the side.

1. Sort the airplane and background pieces into sets, pairing airplane sets to background sets.

2. Sew A and A-reverse to the sides of B.

3. Sew E and E-reverse to the sides of F.

4. Sew a G rectangle to each side of H.

5. Sew the unit from Step 2 to C.

6. Sew the unit from Step 3 to the other side of C.

7. Sew the unit from Step 4 to other side of the Step 3 unit.

8. Repeat Steps 2–7 to make 25 blocks.

9. Appliqué the D circles on the airplane wings with embroidery floss using a blanket stitch.

10. Appliqué triangle I centered on rectangle H to create the tail. Use matching thread.

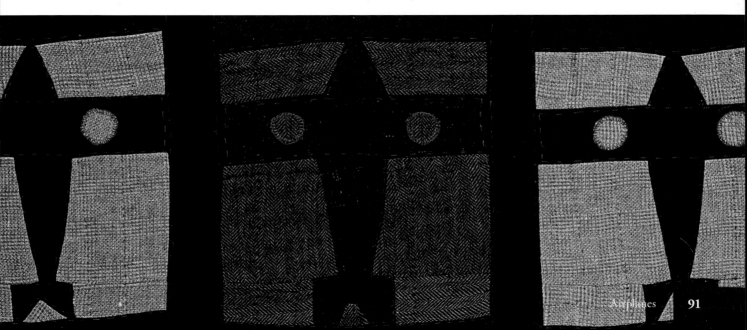

Quilt Assembly

1. Arrange the blocks in a 5 × 5 grid, referring to the quilt photograph (page 86) for color placement.

2. Sew the 3″ × 12″ sashing strips between the blocks in each column.

3. Sew the 73″-long sashing strips between the columns.

4. Sew 68″-long top and bottom borders to the upper and lower edges.

Finishing

To Finish Like the Original Quilt

1. Layer the quilt top right side up on the batting, and place the backing right side down on top of the quilt top. Pin around the edges.

2. Stitch around the edges using a ¼″ seam allowance and leaving a 12″ opening to turn right side out.

3. Turn the quilt right side out and carefully press the edges.

4. Hand stitch the opening closed.

5. Quilt as desired. The original quilt is hand quilted with perle cotton using large stitches around the edges of the airplane, outside each block, and along the edges of the vertical sashing and the borders.

To Finish the Quilt with Binding

1. Layer the quilt top, batting, and backing.

2. Baste using your preferred method.

3. Quilt as desired. The original quilt is hand quilted with perle cotton using large stitches around the edges of each airplane, outside each block, and along the edges of the vertical sashing and the borders.

4. Bind the quilt using your preferred method and a ½″ seam allowance.

Quilt assembly

Airplanes
Smaller Version

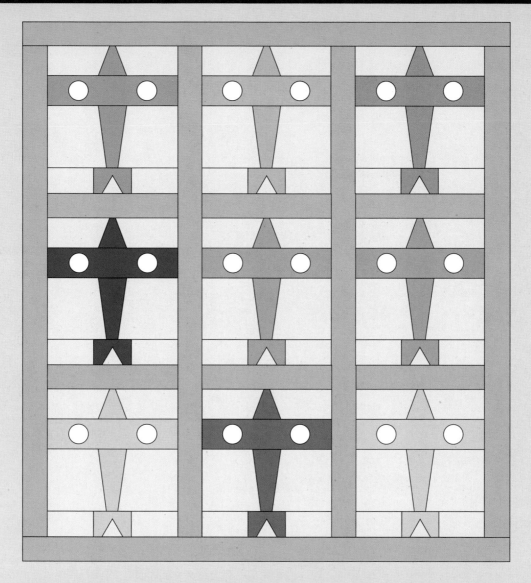

Make 9 blocks and add side borders to create a smaller version that is 45″ × 48″.

Materials

Yardage requirements are based on 40"-wide fabric.

Background: 1⅛ yards

Airplanes: ⅞ yard (or 9 pieces 10" × 13")

Sashing and borders: 1 yard

Binding: ⅝ yard to make ½" finished double-fold binding

Backing: 53" × 56"

Batting: 53" × 56"

Cutting

Make templates A, B, D, E, F, and I using Airplane patterns (pullout pages P1 and P2). The original D circle was raw-edge appliquéd. Add your preferred seam allowance to appliqué patterns D and I. All other patterns include a ¼" seam allowance.

Background

- Cut 3 strips 5¾" × width of fabric; subcut 9 each of patterns E, E-reverse, and I.

- Cut 3 strips 3" × width of fabric; subcut 9 each of patterns A and A-reverse, and 18 of pattern D.

- Cut 3 strips 2¾" × width of fabric; subcut 18 rectangles 2¾" × 4½" for G.

Airplanes

- Cut 1 strip 5¾" × width of fabric; subcut 9 of pattern F.

- Cut 4 strips 3" × width of fabric; subcut 9 of pattern B and 9 rectangles 3" × 12" for C.

- Cut 1 strip 2¾" × width of fabric; subcut 9 rectangles 2¾" × 4" for H.

Sashing and borders

- Cut 9 strips 3" × width of fabric; sew 7 strips together end to end; subcut into 2 strips 3" × 45" and 4 strips 3" × 43" for sashing and borders; subcut 6 sashing rectangles 3" × 12" from the remaining strips.

Binding

- Cut 6 strips 3⅛" × width of fabric.

Refer to Construction (page 90) to make the quilt. Add the side borders before the top and bottom borders.

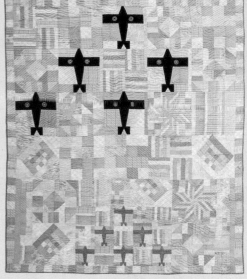

Missing Man Memorial, by Christine Turner, 65" × 77", 2015

Christine was inspired by the earthy colors in the original and some marvelous indigo fabrics brought back from Japan by her husband upon return from military travel. She made this quilt using an assortment of low-volume neutrals and traditional blocks for the background, creating the illusion of fields viewed from high up in the air. The airplanes are shadowed on the ground. "As a military spouse, I saw many of these formations," said Christine, whose plan for the quilt came in a dream.

Stacked Bars

FINISHED QUILT: 70½" × 77½"

FINISHED COLUMN WIDTH: 9½" (6 columns)

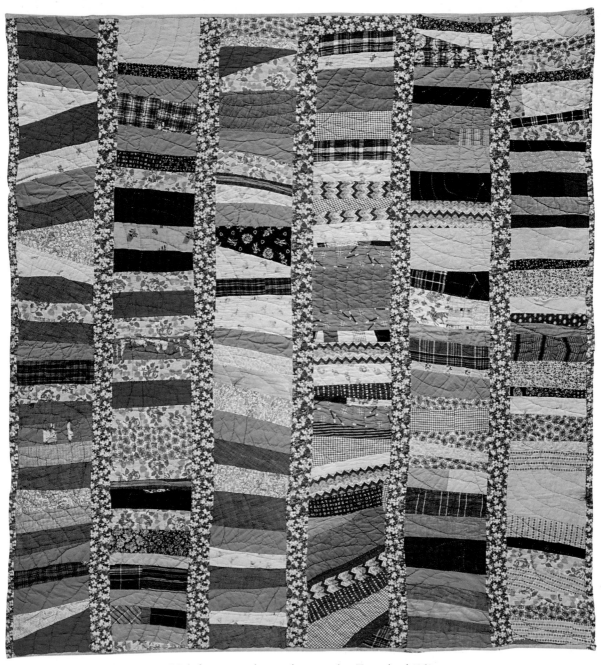

Made from cottons by an unknown maker; Texas; dated 1960

Modern Roots—Today's Quilts from Yesterday's Inspiration

Improvisation is an important element of modernism. Some of the most memorable examples went on display in 2002 with the exhibition "The Quilts of Gee's Bend," which revealed a tradition of improvisational quiltmaking among African-American residents in a small, isolated community in Alabama. Gee's Bend, now called Boykin, was originally populated by the Pettway family and its slaves; several of the quiltmakers of Gee's Bend are descended from the Pettway slaves.

One of the most famous quilts of Gee's Bend was made by Jessie Pettway in the 1950s using red, purple-gray, and orange bars, and string-pieced columns. It was among the select group of quilts that appeared on U.S. postage stamps released in 2006. It is similar to this Stacked Bars quilt made in Texas by an unknown maker in the 1960s. These quilts appear to be related in style, but since the maker of the Texas quilt is unknown, it is more appropriate to call it improvisational rather than African-American.

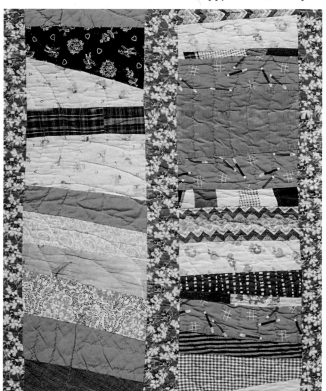

The quilt includes six columns of stacked strips, pieced in a loosely organized style, with a variety of scrappy fabrics, both print and solid. Strips of turquoise, peach, green, black, purple, red, and yellow jump out from the otherwise subdued palette of more neutral fabrics. The vertical sashing is made of an orange floral print fabric. Some of the fabrics have deteriorated and shredded from use and washing. Obviously, the quilt was well loved.

Sometimes called Chinese Coins or Stacked Coins, earlier examples of this pattern occasionally turn up from the Victorian period, with swatches of silks, velvets, and satins, and from the Amish communities, with evenly cut strips of rich, solid cotton sateens. The later, improvisational renditions such as those from Gee's Bend are wonky and imperfect, but that's what gives them soul. At the same time, there is elegance in the imperfection. This design would be a superb scrap buster.

Construction Notes

The original quilt includes a variety of scraps that are 1"–5" tall in columns 9"–9¾" wide. It was bound by folding the backing fabric to the front on the top and bottom, and a traditional, separate binding on the sides. The pattern is written for 9½" columns and traditional binding, yet it is easily adjustable to varying the widths if you desire.

Yardage requirements are based on 40"-wide fabric.

Variety of fabrics: 2¾–4½ yards of scraps (10" minimum width) for bars, **or** use 2 layer cakes (84 squares 10" × 10")

Sashing: 1 yard

Binding: ⅞ yard to make ½" finished double-fold binding

Backing: 78" × 85"

Batting: 78" × 85"

Cutting

Bars

• Cut a variety of scraps at least 10" wide and 1½"–5½" tall. You will need about 180 rectangles and wedges. Refer to the photo (page 96) for shape ideas.

Sashing

• Cut 10 strips 3" × width of fabric. Sew the strips end to end and subcut into 5 strips 3" × 77½".

Binding

• Cut 9 strips 3⅛" × width of fabric.

Construction

Sew or trim all seams to a ¼" seam allowance unless otherwise noted.

Quilt Top Assembly

1. Place 2 bars right sides together and sew them together, varying the angle of the seam as desired. Keep the unit at least 10" wide. Trim the seam allowance to ¼" and press to the side.

2. Continue to add bars until the column is at least 77½" long.

3. Repeat Steps 1 and 2 to make 6 columns.

4. Trim the columns to 10" wide and 77½" long.

5. Sew sashing strips between the columns, pressing the seams toward the sashing.

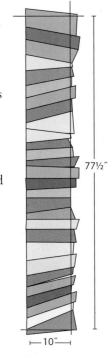

Finishing

1. Layer the quilt top, batting, and backing.

2. Baste using your preferred method.

3. Quilt as desired.

4. Bind the quilt using your preferred method, using a ½" seam allowance.

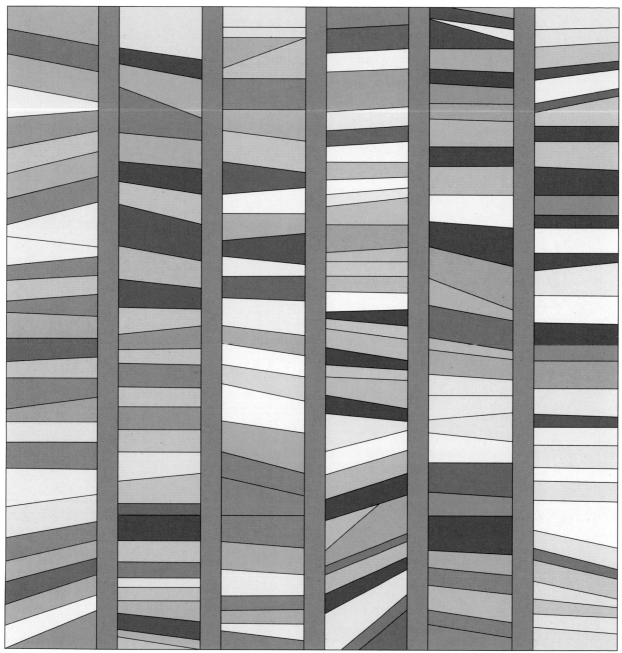

Quilt assembly

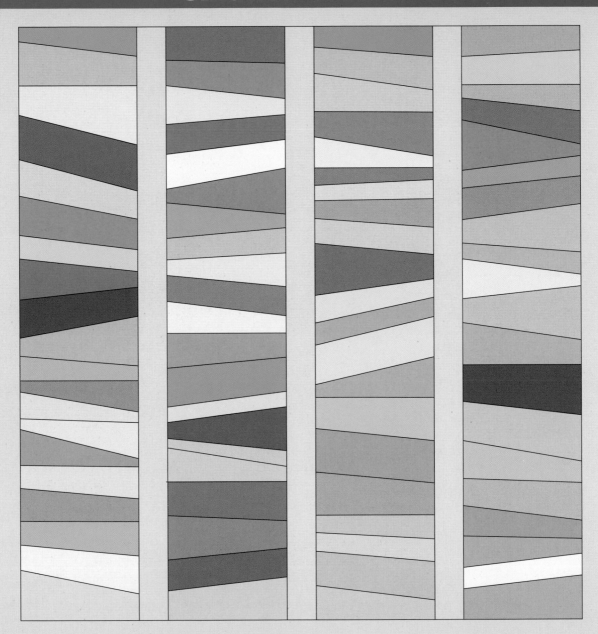

Stacked Bars
Smaller Version

Make 4 columns 50″ long to create a smaller version that is 46″ × 50″.

Materials

Variety of fabrics: 1½–2 yards of scraps (10″ minimum width) for bars, **or** use 1 layer cake (42 squares 10″ × 10″)

Sashing: ½ yard

Binding: ⅝ yard to make ½″ finished double-fold binding

Backing: 54″ × 58″

Batting: 54″ × 58″

Cutting

Bars

• Cut a variety of scraps at least 10″ wide and 1½″–5½″ tall. You will need about 80 rectangles and wedges.

Sashing

• Cut 4 strips 3″ × width of fabric. Sew end to end and subcut into 3 strips 3″ × 50″.

Binding

• Cut 6 strips 3⅛″ × width of fabric.

Refer to Construction (page 98) to make the quilt. Trim columns to 50″ long.

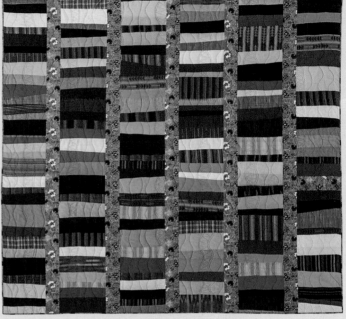

Bars by Krista Hennebury, quilted by Terry Grusendorf, 84″ × 80″, 2015

This quilt was made with Anna Maria Horner prints and wovens from FreeSpirit and Kaffe Fassett wovens from Westminster Fibers. "I was smitten with the sweet floral sashing in the vintage quilt," said Hennebury, who made her version by selecting shot cotton colors matching the selvage dots of her sashing print.

Fabrics from FreeSpirit and Rowan Fabrics

Shadow Box

FINISHED QUILT: 90½" × 105½"

FINISHED BLOCK: 15" × 15" (42 blocks, 6 × 7 setting)

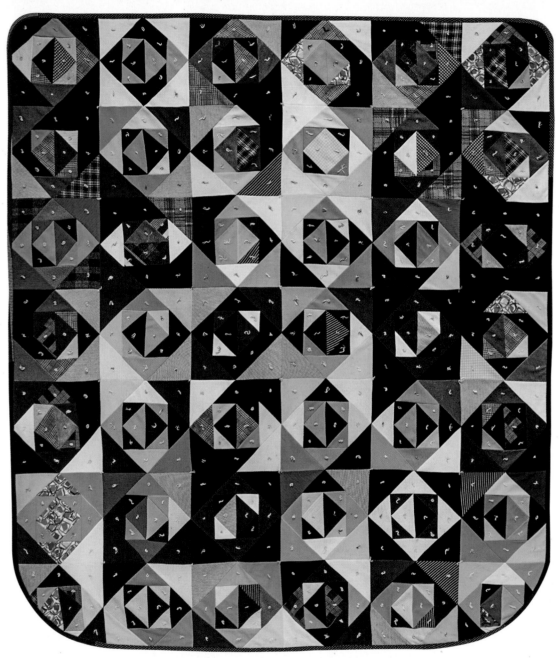

Made from polyester by an unknown maker; Virginia; c. 1970

A big concern with old quilts is color loss. Early dyes can disperse with washing and fade from exposure to light. Sometimes quilts end up looking nothing like they did originally, and determining the true colors is a guessing game. The faded tan seen in nineteenth-century quilts could have been green, lavender, or some other color. If it is an appliquéd vine, perhaps it really would have been green, but if it is a geometric or nonfigural element, it would be hard to say.

Color loss is usually not a problem with the remarkably vibrant quilts of the 1970s. Many of these quilts, like this *Shadow Box* quilt from an unknown maker in Virginia, were made of synthetic fabrics such as polyester double knit. Resistance to fading was one characteristic of the chemically created fiber. It was also stretchy and durable, and it resisted fraying. In garments, polyester double knit was scratchy, hot in the summer, and not warm in the winter, and it held stains. Its popularity in clothing and in quilts was brief.

In the early 1960s, a process called solution dyeing allowed the pigment to be incorporated into the

polyester while the fabric was still a chemical solution. Other fibers such as cotton and wool start as white or light and are immersion dyed. With solution dyeing, the resulting fiber was one color to the core and incredibly colorfast.

Quilts of the middle to late twentieth century are on trend right now. Looking at the quilts of the period can inspire many ideas. There was experimentation with color, and quiltmakers used the most modern materials available. At the same time there are things we can learn from the quilts that we may not want to repeat, such as the materials and methods of finishing. Today, this quilt would probably be made of cottons and quilted rather than tied.

The Shadow Box quilt is made with half-square triangles in a variety of polyester double knit fabrics—light and bright, dark and saturated, plaid and print. In this design, the repetition of triangles allows the quilter to play with intensity, value, and hue. It is dynamic, no matter how you look at it—a great design for mixing fabrics or using a more limited palette such as low volume with pops of color.

Construction Notes

There are more than 30 different colors in the original version of this quilt. The values range from dark to bright colors, with a few prints and plaids thrown into the mix. The original quilt has a ³⁄₄"-wide single-fold binding. Yardage calculations below include this style and ¹⁄₂"-wide double-fold binding.

Materials

The materials list includes quantities for 60"-wide double-knit fabric, or 40"-wide cotton fabric, including binding.

60"-wide fabric: A total of 6⅜ yards in a variety of colors and prints

or

40"-wide fabric: A total of 10 yards in a variety of colors and prints.

Binding: ⅞ yard of 60"-wide fabric to make ¾" finished single-fold binding
or 1⅛ yards of 40"-wide fabric to make ½" finished double-fold binding

Perle cotton: optional, to tie the quilt

Backing: 98" × 113"

Batting: 98" × 113"

Cutting

Blocks

• Cut 84 squares 8⅜" × 8⅜"; cut the squares in half once diagonally for 168 D triangles.

• Cut 126 squares 6¼" × 6¼"; cut the squares in half once diagonally for 84 A triangles and 168 C triangles.

• Cut 84 squares 4⅝" × 4⅝"; cut the squares in half once diagonally for 168 B triangles.

Binding

60"-WIDE FABRIC:

• Cut 8 strips 3⅛" × width of fabric.

or

40"-WIDE FABRIC:

• Cut 11 strips 3⅛" × width of fabric.

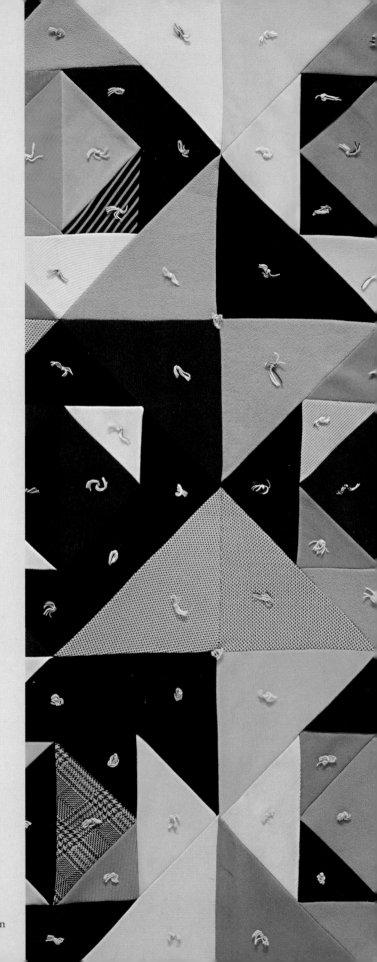

Construction

Sew all seams with a ¼" seam allowance unless otherwise noted.

Block Assembly

Press the seams to the side as noted by arrows.

1. Sew 2 A triangles together to make an A square.

2. Sew 2 B triangles to opposite sides of an A square.

3. Repeat Step 2 to sew 2 more B triangles to the remaining sides of the A square to make an A/B square.

4. Repeat Steps 2 and 3 to add 4 C triangles and then 4 D triangles in the same manner.

5. Repeat Steps 1–4 to make 42 blocks.

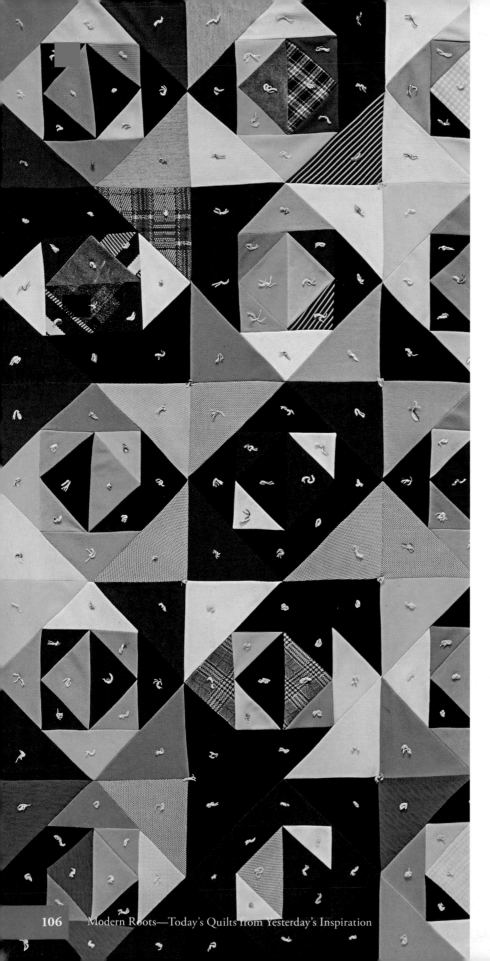

Quilt Assembly

1. Arrange the blocks in a 6 × 7 grid.

2. Sew 6 blocks together to complete each row.

3. Sew the 7 rows together.

Finishing

1. Layer the quilt top, batting, and backing.

2. Baste using your preferred method.

3. Quilt as desired or tie the quilt with perle cotton, placing a knot in the center of each triangle.

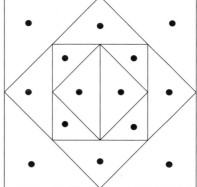

4. If desired, trim the corners using the Shadow Box Corner pattern (pullout page P1).

5. Bind the quilt using your preferred method, with ½″ or ¾″ seam allowance.

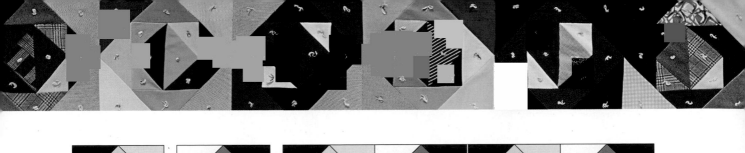

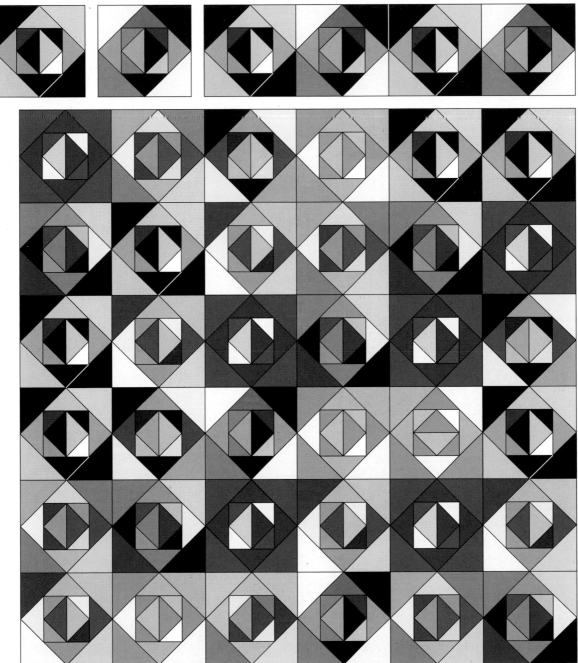

Quilt assembly

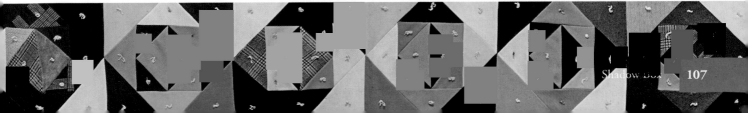

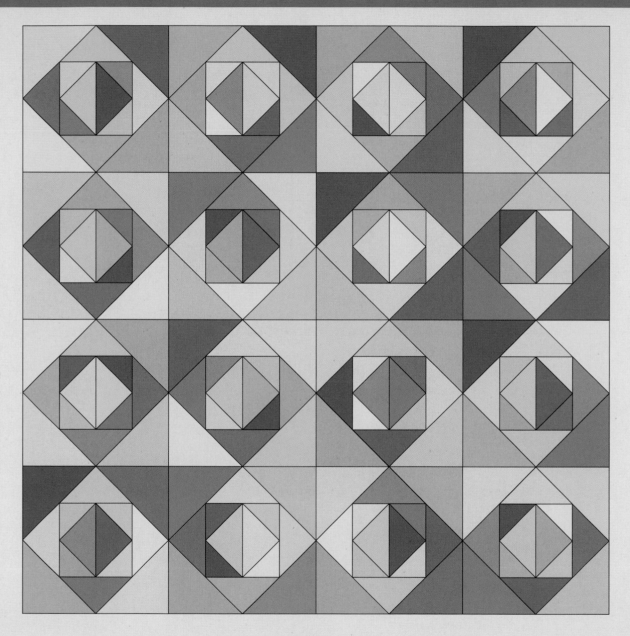

Make 16 blocks to create a smaller version that is 60½″ × 60½″.

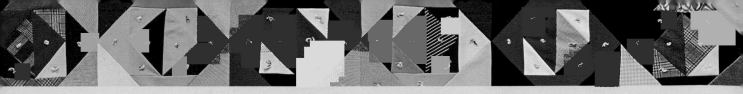

Materials

Yardage requirements are based on 40"-wide fabric.

Variety of fabrics: 4 yards total in a variety of colors and prints

Binding: ¾ yard to make ½" finished double-fold binding

Backing: 68" × 68"

Batting: 68" × 68"

Cutting

Blocks

• Cut 32 squares 8⅜" × 8⅜"; cut the squares in half once diagonally for D triangles.

• Cut 48 squares 6¼" × 6¼"; cut the squares in half once diagonally for 32 A triangles and 64 C triangles.

• Cut 32 squares 4⅝" × 4⅝"; cut the squares in half once diagonally for 64 B triangles.

Binding

• Cut 7 strips 3⅛" × width of fabric.

Refer to Construction (page 105) to make the quilt. Use ½" seam allowance for binding.

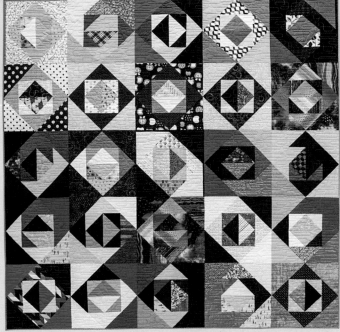

Shadowbox, by members of the Portland Modern Quilt Guild (Juline Bajada, Maria Cardenas, Betty Colburn, Virginia Hammon, Kory Keller, Jolene Knight, Anne Matlak, Mary Jo Morris, Jo Noble, Andrea Ramsey, Nancy Schaefer, Annie Tinnesand, and Dawn White; assembled and quilted by Jolene Knight), 74" × 73", 2015

This modern-day rendition of an already modern-looking 1970s quilt was a group project. It was planned as a "stash buster" and included a wide variety of fabrics. Bill Volckening designed one of the fabrics, called Green Alien Space Baby, using Spoonflower.

Bill Volckening calls himself a quilt magnet—he has an uncanny ability to find great quilts. When Bill bought his first quilt in 1989, he did not intend to become a quilt collector. He just wanted one quilt for wall display. Soon, he realized the quilt was too old and valuable to hang year-round, so he found another quilt and planned to rotate the two. For the next 20 years, collecting quilts was Bill's hobby. He would buy quilts as his decor changed, but nobody knew about the collection except close friends and family.

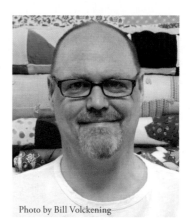

Photo by Bill Volckening

In 2009, Bill showed his collection of New York Beauty quilts to a local quilt study group, and the quilt history enthusiasts gave him a new perspective on his collection. It was something more than he ever imagined. He made an effort to share the quilts from that point forward, and it led to many opportunities—exhibitions and publications around the globe. His first book was *New York Beauty: Quilts from the Volckening Collection* (by Quiltmania).

Bill's award-winning blog *Wonkyworld* reveals the process of collecting from the perspective of a twenty-first-century collector. It is about the thrill of the hunt and the bounty, and it is the ever-unfolding story of his quilt journey. In addition to the quilt collection, Bill has an extensive library with many rare titles and signed editions, a small ephemera collection, and a wonderful network of people with specialized knowledge about all things quilt related.

Bill studied at Rhode Island School of Design (1984–1986) and the School of Visual Arts in New York (BFA, 1988). He was also part of a selective graduate program at New York University and the International Center of Photography (MA, 1991). He is an award-winning photographer and quiltmaker, and his work has been published globally. Quilts from The Volckening Collection have been exhibited from New York to Tokyo and appeared in various publications worldwide.

Resources

Suggested books on quiltmaking

Anderson, Alex. *All Things Quilting with Alex Anderson* (by C&T Publishing)

Bonner, Natalia. *Beginner's Guide to Free-Motion Quilting* (by Stash Books)

Cameli, Christina. *First Steps to Free-Motion Quilting* (by Stash Books)

Dick, Jenifer. *The Modern Appliqué Workbook* (by Stash Books)

Goldsmith, Becky, and Linda Jenkins. *The Best Ever Appliqué Sampler from Piece O' Cake Designs* (by C&T Publishing)

Hartman, Elizabeth. *The Practical Guide to Patchwork* (by Stash Books)

Walters, Angela. *Free-Motion Quilting with Angela Walters* (by Stash Books)